Painting
with
Mixed Media

Painting with Mixed Media

Geri Greenman
and Paula Guhin

STACKPOLE
BOOKS

Published by
STACKPOLE BOOKS
5067 Ritter Road
Mechanicsburg, PA 17055
www.stackpolebooks.com

Printed in U.S.A.

10 9 8 7 6 5 4 3 2 1

First edition

Cover design by Tessa J. Sweigert

Library of Congress Cataloging-in-Publication Data

Greenman, Geri.
 Painting with mixed media / Geri Greenman and Paula Guhin. — First edition.
 pages cm
 ISBN 978-0-8117-0360-4
 1. Mixed media painting—Technique. I. Guhin, Paula. II. Title.

ND1505.G75 2012
751.4--dc23

2012005462

To my parents, in loving memory.

—P. G.

To my wonderful family, whose love
and support give my life color.

—G. G.

Contents

A Note on Safety

Work in a ventilated area when using powders, solvents, or sprays. Read safety information on the packaging, and use caution with combustibles. Due to differing conditions, materials, usage, and skill levels, we disclaim any liability for failure or harm.

Before You Wade Right In

This book is a celebration of—yes—painting, combined with a wealth of other readily available materials. We present a wide range of exciting techniques and media, together with drawing, layering, collaging, texturizing, and more. Mix things up! Paint with abandon, discovering media fusions that stir the imagination and rouse the creative spirit.

This book is meant to assist and inspire not only beginners to painting and mixed media but also those who seek to expand their knowledge and skills, to explore new vistas. It's for boomers, late bloomers, student artists, experienced artists, and anyone interested in the countless possibilities of paint combined with other media.

Try intuitive play, unconventional techniques, and alternative surfaces. Recent developments in art media have opened up worlds of artistic discovery. Dare to be inventive and take nontraditional approaches!

We begin with many marvelous materials and tools and a plethora of appealing papers and other substrates. Every subsequent chapter features a different painting medium fused in funky ways with other materials.

Each of those chapters ends with a Float Your Boat Farther section, featuring spin-off ideas that prompt you to take new directions and spur your innovative spirit. To fuel the muse!

We hope you'll find the tip boxes throughout these pages to be valuable. Painting Pointers offer artistic advice and helpful hints; they're little "guides on the side."

And, if you're like us, buying lots of expensive art supplies is beyond your budget. So our thrifty tips, Savvy Substitutions, will come in handy.

Green Scene recommendations are eco-friendly, natch. We'll show you how to value many old items—from rusting kitchen gadgets to broken toys—and use them in a fresh way. Help prevent waste by salvaging serviceable "junk" and discards. As a bonus, this will help stretch your pennies!

Stir up some creative fire with the stimulating Portfolio of Art, a showcase packed with extraordinary examples by many talented artists. In addition, we include a list of vendors and manufacturers of art materials in the appendix.

Bring this book into *play* (pun intended) as you investigate and experiment further.

And now, surf's up! Are you stoked?

Give your imagination free rein and allow it to gallop.
—*Marquis de Sade (paraphrased)*

Diving In with Materials, Tools, and Substrates

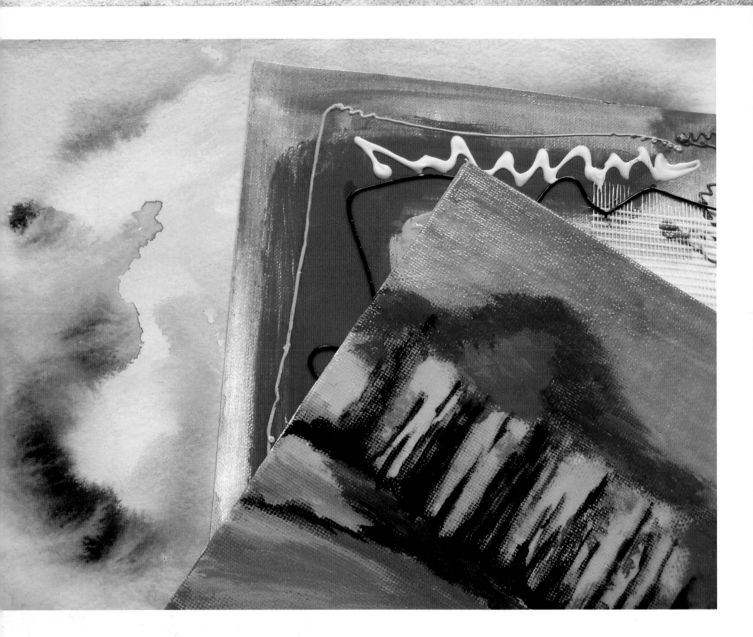

The conventional art materials mentioned here are categorized broadly. In addition, we've made lists of ephemera, odds and ends, and household items that can be used to make art. Collage is a powerful tool for any painter. Use it to add texture, personal imagery, memorabilia, and more to your paintings. And layering adds a new dimension to the work in several senses of the word!

ART MEDIA

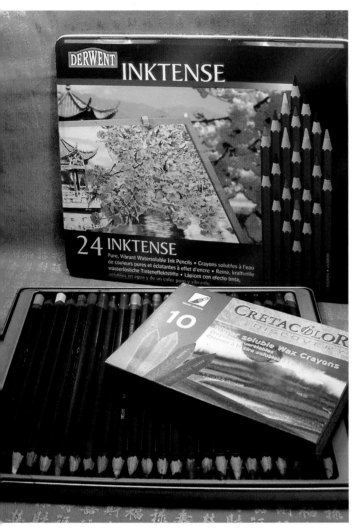

Acrylic paints and mediums
Charcoal pencils
Charcoal sticks
Colored pencils
Conté crayons
Conté pencils
Gel pens
Gesso
Gouache
Graphite
Inks of all types

Markers of all kinds
Masking fluid
Oil and chalk pastels
Oil paints and mediums
Pencils of several types
Solvents
Spray paint
Tempera paint
Varnishes
Watercolor paint
Wax and grease crayons
White glue

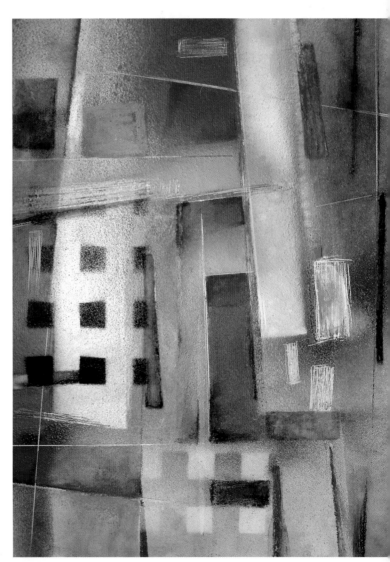

Spray paint, stencil, tissue, water-soluble pencils, sgraffito (read more about sgraffito on page 55).

ODDS AND ENDS

These common household items likely can be found in the kitchen, laundry room, or workroom. Find a separate list of tools starting on page 6.

Acetone	Lace
Beads	Laundry bleach
Burlap	Margarita salt
Buttons	Mesh bags
Cheesecloth	Non-slip rubber
China markers	Paraffin
CitraSolv	Patina solutions
Crackle medium	Petroleum jelly
Doilies	Plastic wrap
Drywall compound	Ribbons
Fabric dye	Rubber gloves
Fibers	Sandpaper
Floss	Spray paint
Foreign coins	Wallpaper paste
Gauze	Waxed paper
House paint	Wire
Kosher salt	

Low- or No-Cost!

This flotsam and jetsam is very cheap or (wait for it) free! Ephemera and repurposed items can become art.

Bones	Paint chips
Candles	Playing cards
Candy wrappers	Postage stamps
Cardboard	Pressed leaves
Charms	Puzzle pieces
Clock parts	Rags
Clothespins	Receipts
Costume jewelry	Sand
Crushed eggshells	Sawdust
Dictionary pages	Sea glass
Dominoes	Seashells
Dress patterns	Sheet music
Fabric scraps	Shopping lists
Feathers	Small toys
Game pieces	Sticks
Maps	Stones
Metal foil	String
Nuts and bolts	Styrofoam
Old calendars	Ticket stubs
Old keys	Washers
Old report cards	Wrapping paper

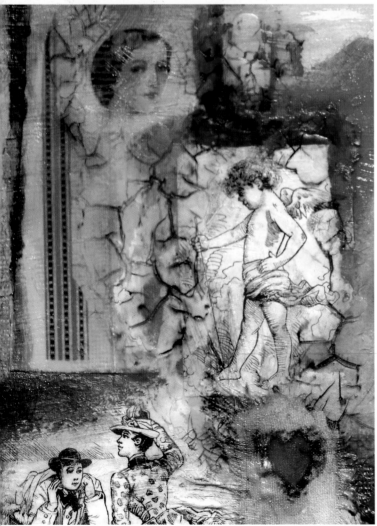

Vintage images, acrylic mediums, and paint.

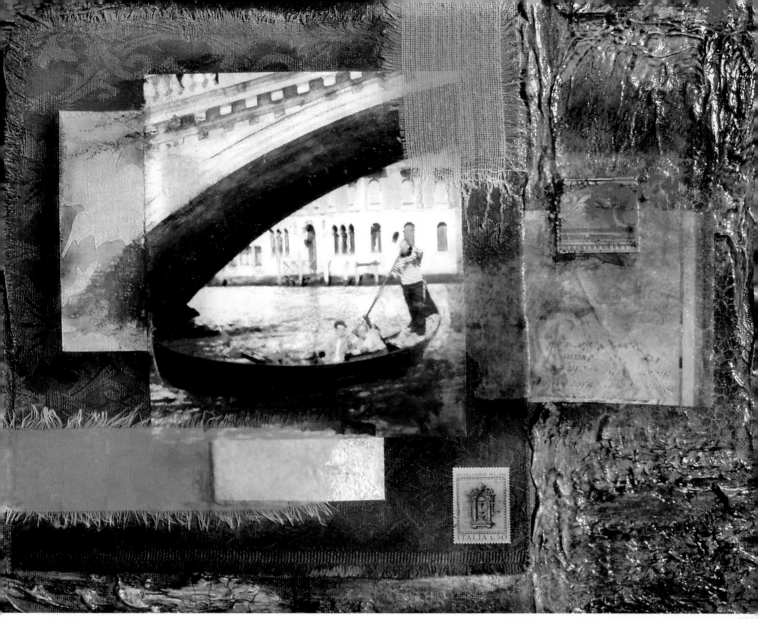

"Venezia," by Paula. Acrylic paint and modeling paste, inks, fabric, and an original photograph.

Green Scene

Take a good look at product packaging and junk mail before you discard it. Surely some of the words, patterns, and images can be incorporated into your art!

TOOLS

Relax . . . You likely won't need *all* the items listed below!

Traditional Art Tools

Brushes
Craft knife
Drawing board
Easel
Erasers
Fixative
Painting knives
Palette
Palette knives
Paper trimmer

Pencil sharpener
Pens
Ruler
Scissors
Scratch tools
Shaper tool
Tapes, assorted
Tortillons (blending stumps)
Transfer paper

Atypical Tools

Artists have been using craft sticks forever, it seems, and they long ago realized the convenience of foam brushes, paint rollers, and daubers. Alternative tools can also be found in the garage (house-painting brushes, for one), in the bathroom (cotton balls, cotton swabs, and more), even in a billfold (old credit cards). Here are more art tool ideas:

Bamboo skewers
Brads
Bubble wrap
Bulldog clips
CD cases
CDs
Dental tools
Desk blotters
Eyedroppers and pipettes
Gummed labels
Hair combs
Hole punch
Hole reinforcement
 stickers
Iron
Knitting needles

Makeup brushes and
 applicators
Old toothbrushes
Paper clips
Post-It notes
Putty knives
Rubber cement
Staples
Steel wool
Stencils
Stickers
Thumbtacks
Tile adhesive applicators
Toothpicks
Transparencies
Whiteout pens

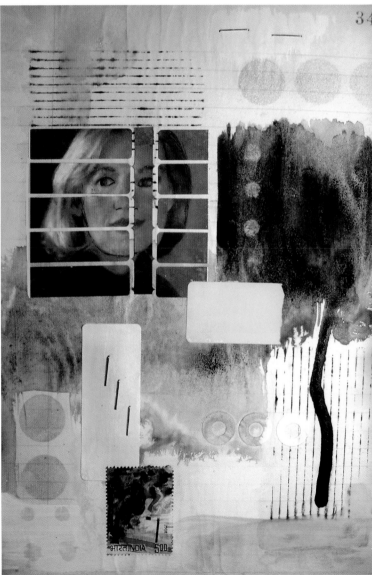

Hole reinforcements, address labels, staples, stamp pad ink, a postage stamp, and more went into this 8-by-10-inch piece.

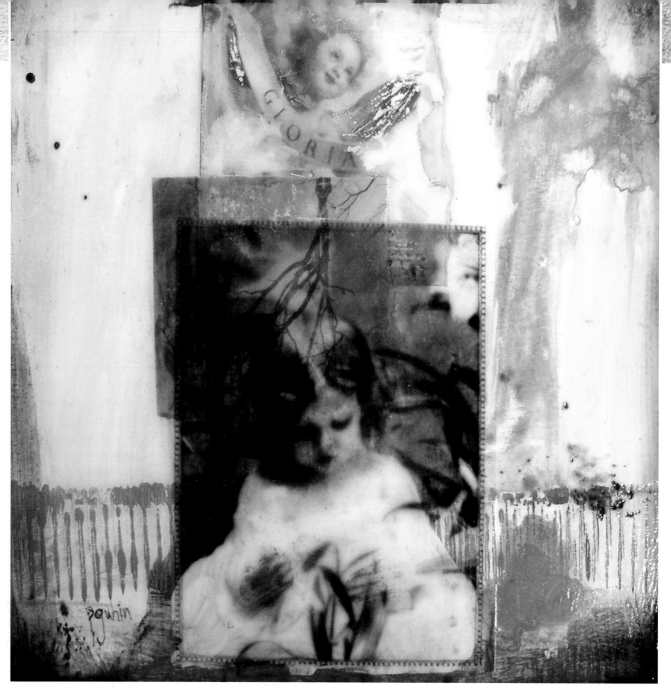

An artwork done with a transparency, a found image, acrylic paint, and inks.

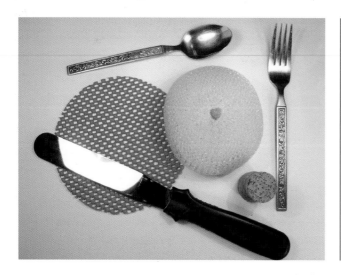

From the Galley

A great number of kitchen items can be used in art-making.

Aluminum foil	Pie tins
Cookie cutters	Plastic containers
Corks	Potato mashers
Doilies	Roasting pans
Drinking straws	Scrubbers
Egg cartons	Shaker-top jars
Forks	Sponges
Knives	Spoons
Muffin tins	Squeeze bottles
Pastry knives	String

IMAGERY

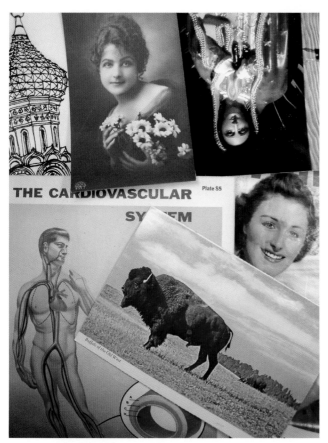

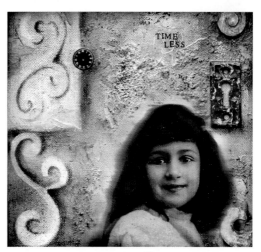

Paula's mixed-media collage includes a photocopy of an antique portrait. Vintage images add a classic heritage look—search through your stored things, your mother's, your grandmother's! Use copies of precious images in art-making.

Incorporating images and symbols into artwork can add another level of meaning. Find inspiration in the sources below.

Computer-generated images
Hand-drawn sketches
Index prints
Magazine pages

Photo-booth strips
Photocopies
Postcards
Spare photos
Vintage book pages

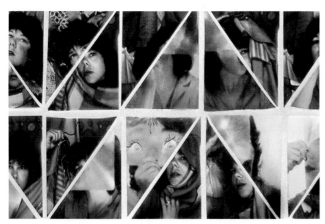

This detail shows how Geri used photo-booth pictures, oils, and watercolor markers.

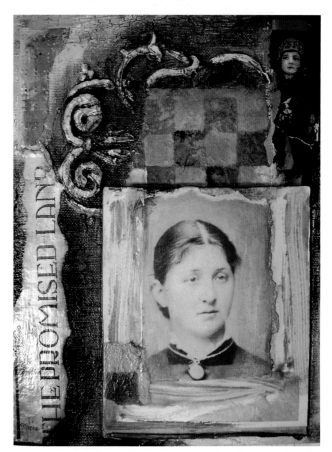

The actual cabinet photo used in this mixed media piece, entitled "Heritage," was not valued or treasured by anyone. It was given worth in this artwork.

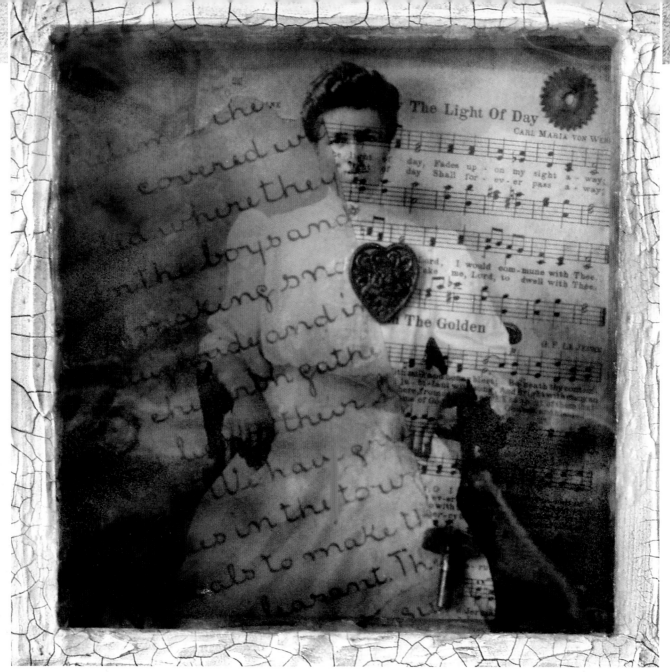

Paula inkjet-printed a transparency of her grandmother Emma to use in this dimensional work.

SUBSTRATES

Support your art! Select the right foundation, whether canvas, paper, or another surface.

Papers

Asian papers
Drawing papers
Homemade papers
Italian papers
Newsprint

Pastels papers
Printmaking papers
Rice papers
Watercolor papers

Canvases

Gallery-wrapped canvas (bottom), canvas with stretcher side up (middle), and canvas panel (top). Canvases come in a wide range of types, shapes, and sizes. Flat canvas panels are easier on the budget than the traditional stretched canvases (canvas stretched over a wooden framework). You can even purchase canvas-surfaced boards or pads of canvas sheets. Most store-bought canvases are preprimed and ready to use.

Painting Pointer

Brian Sullivan sent us this tip: "Since I work large and I am very prolific, I cannot afford to purchase large-scale canvases. By creating my own large canvases, I can control the quality and size, and save money, too. I make six at a time for the sake of convenience."

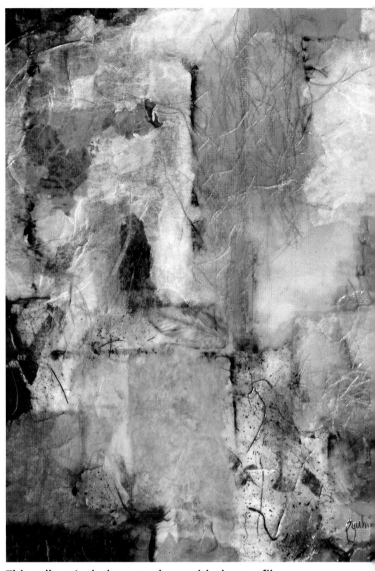

This collage/painting was done with tissues, fibrous specialty papers, acrylic paint, and ink.

Paint On! Other Surfaces

Acetates and assorted films	Hardboard
Bone	Illustration board
Bristol board	Leather
Canvasboard	Lutradur
Cardboard	Masonite
Clayboard	Matboard
Dura-lar	Metal
Fabric	Museum board
Fired clay	Mylar
Foam core	Plasterboard
Gesso board	Plexiglas
Glass	Wood

Top to bottom: illustration board, masonite, plexiglas, and copper.

The burlap used for the smaller insert had a much more open weave than the other piece.

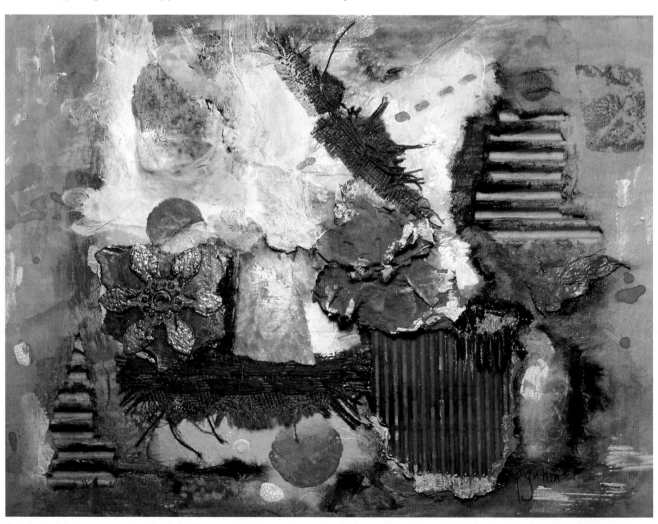

This artwork was made on and of corrugated cardboard, with acrylics, inks, papers, stone, and fibers.

"The artist produces for the
liberation of his soul."
—*W. Somerset Maugham*

2

Make Waves
with Acrylics

Acrylic paints are convenient, practical, resilient, enduring . . . sooo many positive adjectives!

They thin with water and dry (quickly) to a permanent finish. Buy them in jars, bottles, tubes, paint pens, pots, and more. Consistencies vary from thick, heavy-bodied paints to very fluid acrylics. The vast array of acrylics includes dimensional paints, glitter paints, fabric paints, neon colors, and interference pigments, to name a few.

Interference paints are opalescent colors that seem to change when viewed from different perspectives. Green-blue and fine gold were used here on a black surface.

ACRYLIC ADDITIVES AND MORE

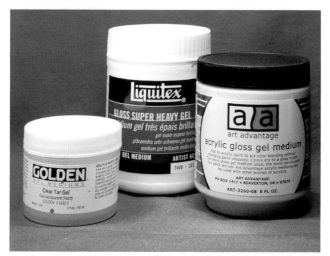

Many compatible media can be mixed with acrylic paints for spectacular results. Alter the color, consistency, finish, and transparency. Extend the paint to make it go further.

Gloss or Matte, Liquid or Gel?

Fluid polymer mediums, glossy or matte, are milky looking until they dry clear. They can be used as an adhesive or to increase the transparency of paint. Here, liquid acrylic paint has been added.

Gel mediums are available in soft, medium, heavy, or extra-heavy varieties. Finishes include gloss, semi-gloss, and matte. Use them for holding texture, extending colors, and increasing translucence. Gels are often employed as a convenient adhesive.

Clear tar gel is a resinous, syrupy acrylic product that can be used in many ways as a medium.

Many products act as both adhesives and sealants and dry clear as glass.

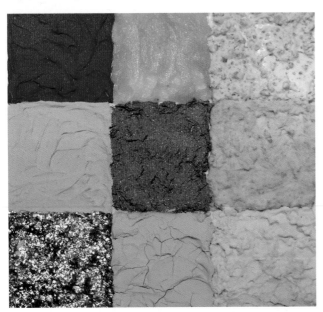

This patchwork of texture gels and stucco products has not been painted yet. Texture gel mediums have additives such as tiny glass beads, mica, pumice, sand, or threads. They can be mixed with acrylics or applied, allowed to dry, and painted afterward. Various specialty media absorb paints differently.

Acrylic Pastes, Glazes, and Other Media

Modeling paste is excellent for creating sculptural effects or painting in the *impasto* style. Since regular hard modeling or molding paste shrinks as it dries, cracks will form if a very thick layer is applied. Light molding paste is more flexible and softer.

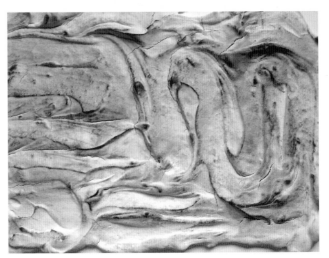

Charcoal powder was rubbed over the dry surface of this hard modeling paste. This accentuates the crevices left by a painting knife.

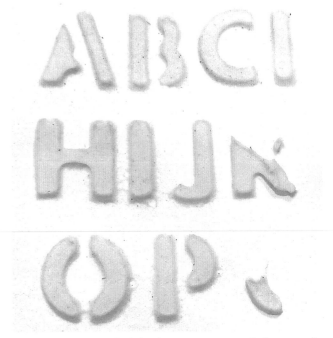

These dimensional alpha letters were made by stenciling modeling paste onto a firm canvas panel. Use a rigid support for modeling paste and crackle paste.

Here, coarse salt has been sprinkled at random into light molding paste while it was still wet. This creates a variation in the texture.

Painting Pointer

Dreama Kattenbraker reminded us of this tip: If you like to layer color, use mediums to create transparent glazes for things that are truly transparent (such as water or skin or sky). As you work, leave a little bit of the previous layer peeking out somewhere, or wipe away some of the still-wet color to reveal layers underneath. If the glaze is too dry, take a small piece of sandpaper and literally sand away top layers to reveal bottom layers.

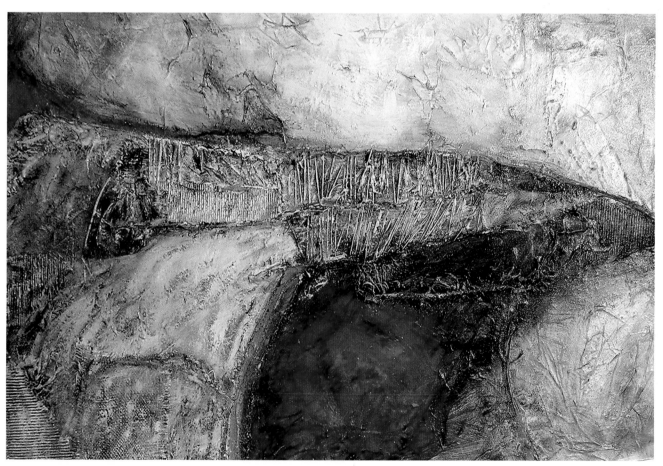

Geri's "Fossil": Acrylic paint, modeling paste, inks, sand, twigs, toothpicks, twine, tissue paper, and oil glazing on canvas over wood.

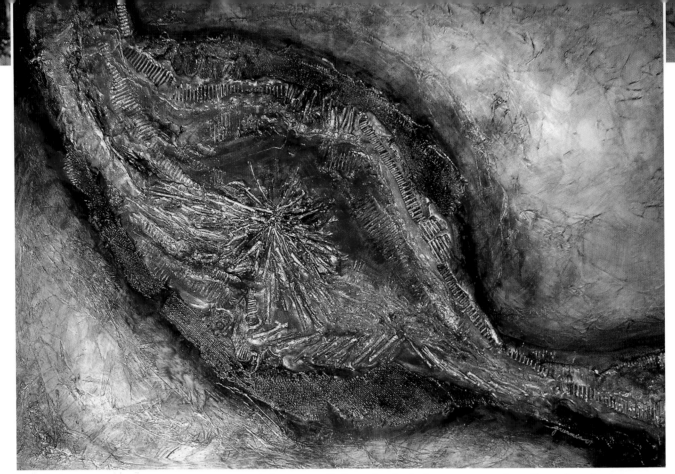

Geri's "Peninsula" consists of similar materials as "Fossil" but also includes corrugated cardboard and canvas pieces.

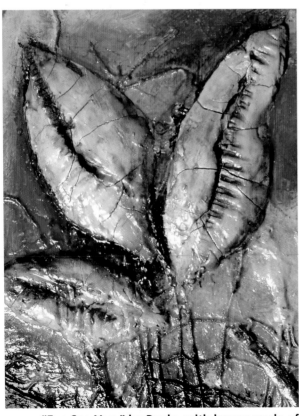

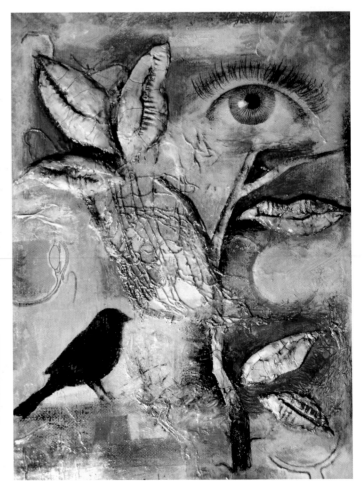

"Eye See You," by Paula, with leaves made of built-up modeling paste.

Crackle paste is a thick white medium that develops—yes—cracks as it dries. The thicker the application, the larger the cracks. As with most acrylic mediums, you can mix it with color before using or paint over it when dry.

Crackle glazes and paints, too, are plentiful on the crafts market.

Finally, ready-to-use acrylic glazes are available in a rainbow of colors. Glazing refers to applying a thin, transparent layer of paint. Such transparent color alters the colors underneath and may enhance texture as well.

Floating medium, also called flow aid, helps in blending and causes colors to run when poured. It comes as either a gel or a liquid. Here, black airbrush ink was spread with the assistance of flow medium.

Yet another product, self-leveling medium, helps produce smooth surfaces without brush marks.

Gesso: Not Just for Priming

Water-based acrylic gesso is a primer meant to be applied to canvas, wood, or other surfaces before painting with acrylics or oils. Traditionally white, gesso now comes in many colors. It dries to an opaque finish.

This small piece by Laura Lein Svencner was made with string and tissue and glazed with sheer yellow acrylic.

Green Scene

Gesso not only primes raw canvas but also covers unsuccessful paintings. Reuse those canvases and failed works on paper! The best thing about creating a new painting over an old one is the elimination of the "blank canvas" syndrome. A tantalizing glimpse of textures and colors can even be allowed to show through in places.

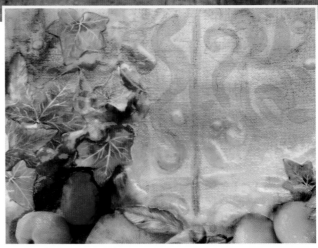

Paint or stamp a design with gesso onto a glossy, non-absorbent surface and let dry. Then wash over it with liquid acrylic, watercolors, or inks (a wash is a thin, watery mixture of paint). After a moment, wipe a damp cloth over the surface to remove excess paint. The gesso "grabs" color better than the background does.

SQUEEZE, PLEASE

Aren't plastic squeeze bottles terrific? Use them to "draw" outlines, borders, words, symbols, and more with paint. Add these elements to a work in progress or begin with them and go on from there.

Tools & Materials
- Squeeze bottle(s) of paint, acrylic medium, craft glue, or fabric resist products
- Substrate
- Other art media and tools of choice

Here's How
1. Fill a clean, empty squirt bottle with medium-thick paint, or buy ready-made paint scribblers or paint writers. Hold the bottle at an angle to the paper or canvas. Make a few test lines on scratch paper to be sure the applicator tip is working properly.

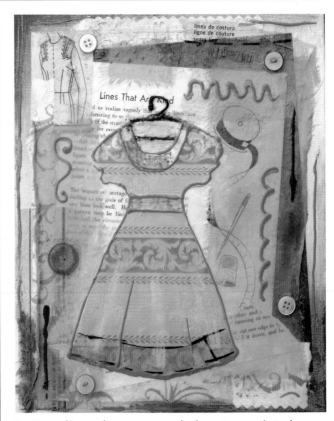

2. Draw lines, shapes, or symbols onto a painted canvas with smooth, flowing strokes while squeezing the bottle. You can even write out words if you wish.

3. Or squeeze out some permanent white glue lines on an unsealed surface and let dry.

4. Paint over the dried glue with thin water-based media (read more about glue lines on page XX).

5. Glue lines were applied to a dry watercolor painting. After the glue dried, diluted acrylic ink was washed over all.

6. Another resist product to try is glossy liquid acrylic, used on an absorbent background. Here it was put on a white, gessoed canvas and allowed to dry before thin acrylic paints were applied.

Painting Pointer

Want thinner lines? If the opening at the tip of a squeeze bottle is too large, wrap cellophane tape around it to form a tiny funnel.

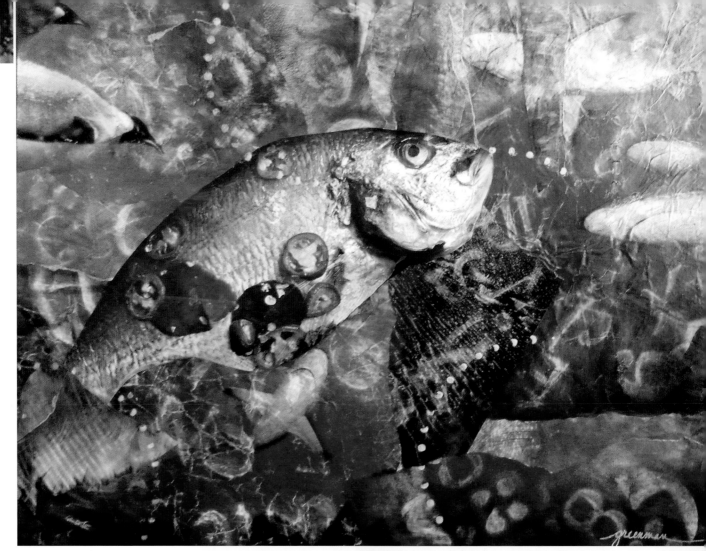

"Swimmin' in the Reign": Many collage artists use treated papers as elements in their paintings. Geri rubs silver polish or sandpaper on magazine papers laid over stencils. Sometimes she crinkles papers, paints acrylics on them, and wipes off most of the paint with a soft rag while the paint is still wet. Some of the paint remains in the grooves. She adds acrylic tints and oil glazes to bring the composition of the piece together.

To complete this work, "Put Your Heart Into Your Art," Geri glazed violet oil paint on top.

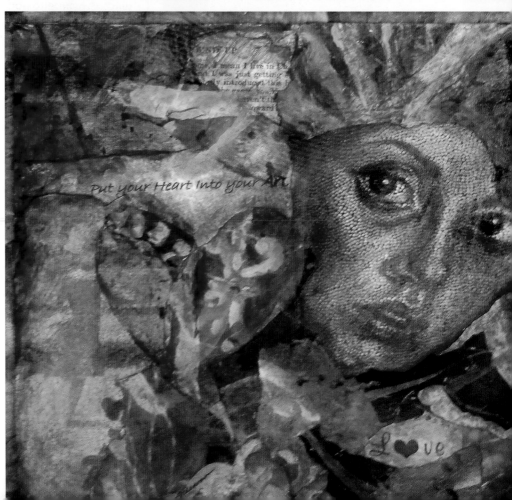

CREATE A PAINTED COLLAGE

Tools & Materials

- Paints, inks, markers, pastels
- Papers and other materials and tools of choice
- Substrate
- Brushes
- Adhesive
- Scissors
- Imagery (optional)
- Varnish (optional)

Here's How

1. Select fabric, ephemera, images, papers—the elements important to your collage/painting. Paint the background first if you wish, or simply arrange the items on the blank substrate in a pleasing composition.

2. Glue the pieces down and let dry. Paint, draw, or glaze the piece to add interest, unity, and balance.

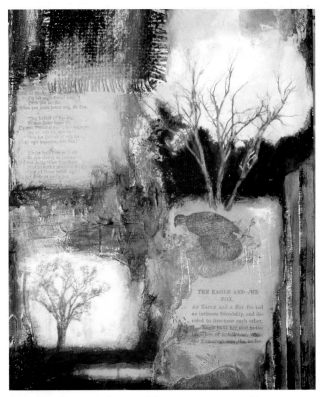

3. Note the use of repetition, contrast, and harmony in the finished piece.

"Between a Rock and . . . ," by Paula, with sand in gesso, crumpled tissues, acrylics, and inks.

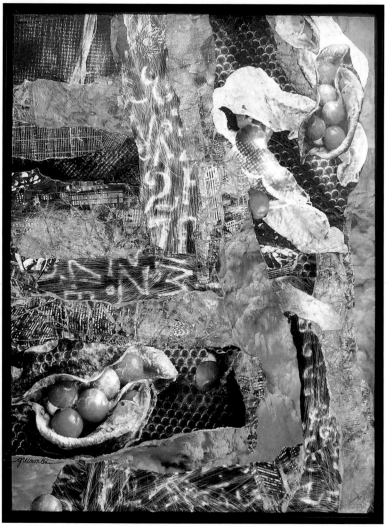

"Emotion Commotion," another piece of Geri's, was done with oils, acrylics, and sanded, crumpled magazine papers. Claybord is the support.

Painting Pointer

Rub a fabric softener sheet all over your hands before using paint or glue to make cleanup easier.

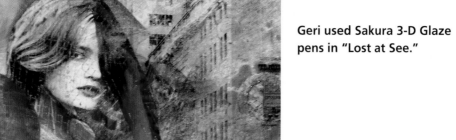

Geri used Sakura 3-D Glaze
pens in "Lost at See."

"Muddy Waters," by Geri.

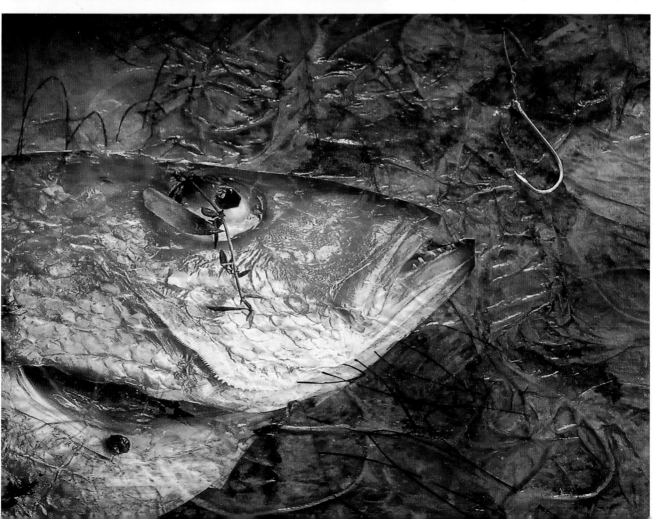

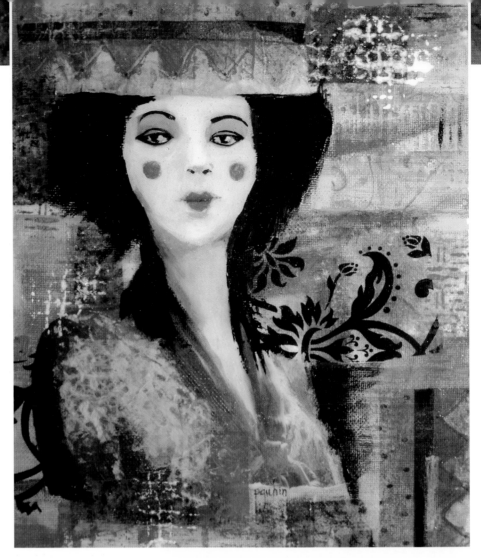

"Clown Queen," a collage/painting by Paula, was done with decorative napkins, acrylics, and inks.

Use Your Napkin, Dear

Two different paper napkin designs are shown here adhered to a painted canvas panel. Napkins printed on white or light backgrounds work best.

1. Paint the background first and let dry thoroughly.

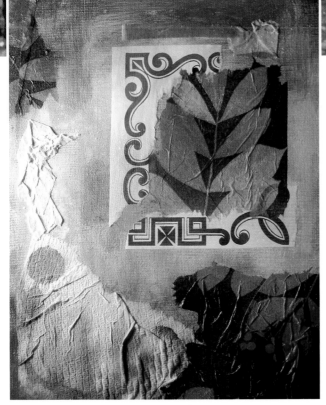

2. Gather materials, including decorative paper napkins. Separate the printed layer, or ply, from the other napkin layers (this adds desirable translucence to the design). Arrange and adhere the elements.

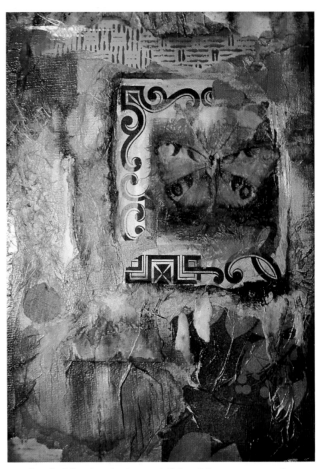

4. The finished painting exhibits rich texture and color.

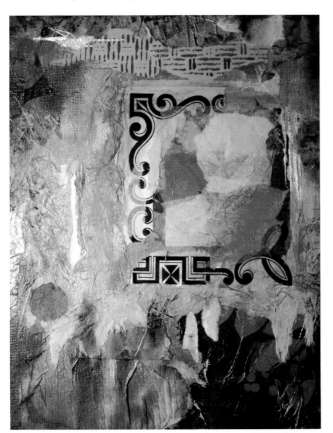

3. When the glue or acrylic medium is dry, paint and make marks with the tools you like. Add contrast with a variety of values from light to dark, and use a range of sizes, too. However, remember that having some recurring elements will give your piece rhythm

Painting Pointer

Acrylic paints should not be washed down the drain. Before cleaning brushes, wipe them thoroughly with a rag.

Paula's "The Crier": acrylics, inks, transfers, peeling and resist effects.

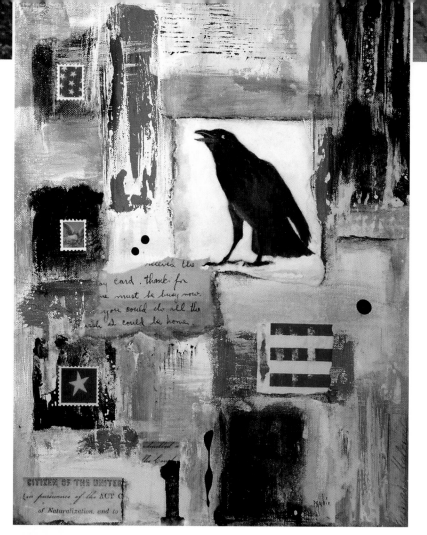

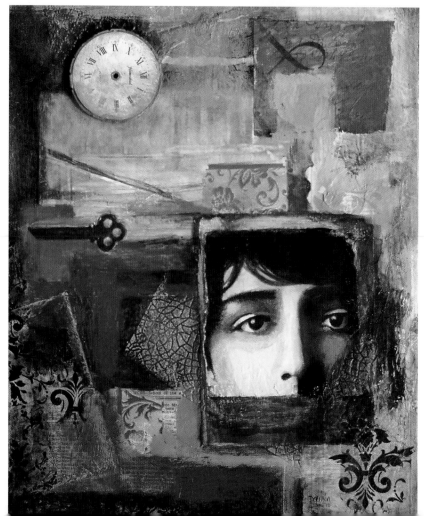

"Eterne," by Paula: acrylics, crackle medium, oil paint marker, printed napkins and other papers, key, clock face.

MAKE A PAINTED MOSAIC

Glazing and painting are two ways to bring together a magazine paper mosaic. Geri's mosaic here is after a painting by Franz Marc.

Here's How

1. Sketch your design on a substrate. Use tracing paper to make a copy of it, enclosing spaces as you go. These shapes (closed lines) will become the mosaic "pieces."

2. Choose magazine papers in the colors, values, and textures you need. Cut out shapes with scissors, using the tracing as a pattern. Glue them where they fit.

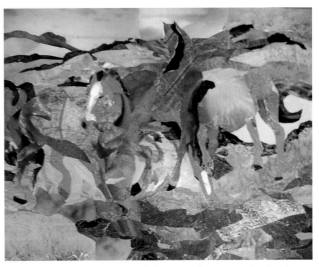

3. Paint washes here and there to better mingle the various textures and colors of the magazine papers. The shapes should show through.

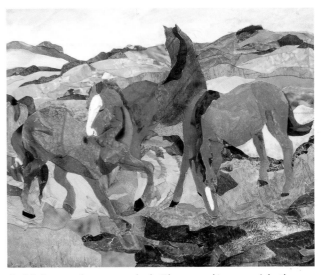

4. Make marks as needed. Glaze and/or varnish the finished piece.

RESISTS ARE IRRESISTIBLE

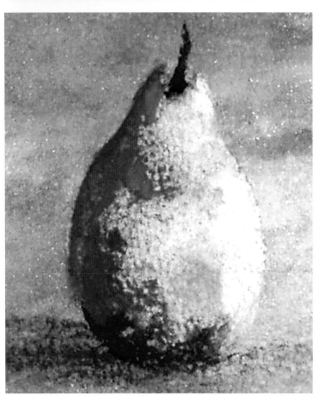

Just as the dried glue or liquid acrylic medium mentioned previously resisted thin washes of water-based paints, so too do other products. Here we'll create waxed paper wonders!

Tools & Materials

- Waxed paper
- Iron
- Scissors
- Pressing sheet
- Paper as substrate
- Water-based paints and inks
- Brushes and other tools
- Water containers
- Rags

Here's How

1. Cut shapes from waxed paper and crumple them for added interest if you wish. Here, two of the shapes have been left smooth. Place the shapes on the substrate and cover them with clean paper before pressing with a hot iron.

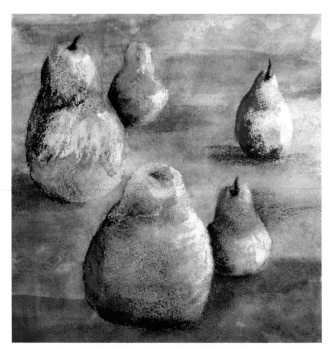

2. Remove when cool and wash over the paper with inks or thin paints. In this example, soft pastel accents finished the work.

FLOAT YOUR BOAT FARTHER

In this section, we present suggestions for even more projects using acrylics with other media. We hope you'll create wonderful artworks using these offshoot ideas.

How Distressing!

Create a peeled-paint effect as background or accent areas in a painting. This time-worn, distressed look is easy: First, apply a base coat of acrylic paint to the support. Let dry. Next, smear on some streaks of petroleum jelly in one direction. Wherever you place the jelly, the background will show through later.

Lightly stroke the surface with another coat of liquid acrylic in a different color. Let the paint gently flow over the jelly. Set aside to dry. Finally, rub a rag over the piece to wipe off loose paint and jelly. Wash the canvas with warm, soapy water to remove greasiness, and pat dry.

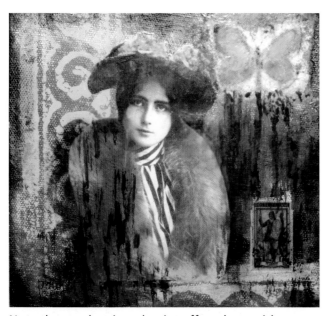

Note the aged, stripped-paint effect done with green and violet in this mixed-media work.

Savvy Substitution

As a resist product, thick hair gel works as well as petroleum jelly.

Skins and Peels

You can use ready-made products with this technique, or you can make your own. Mix liquid acrylic medium or clear tar gel with gel medium, about half and half. Colorize with fluid acrylic paint.

You can even make marbleized acrylic skins by dripping spots of fluid color into the mixture and combing with a toothpick!

Dribble or squeeze the mixture in exciting lines and shapes onto glass, freezer paper, or flexible page-protectors. Once the skins are dry (in a day or two), peel them off and glue them into an artwork. Dried acrylic membranes, elastic and flexible, can also be cut with scissors.

You can also simply soak dried acrylic skins off a glass or plastic palette. These leftovers can be used again as elements in a collage.

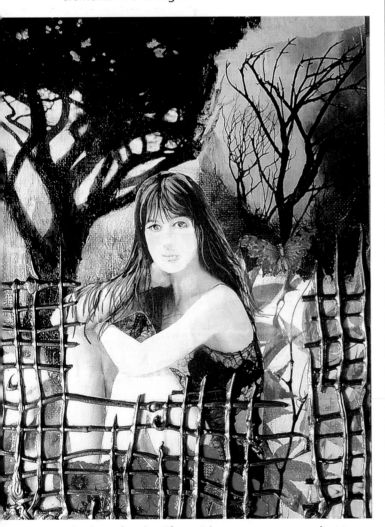

The lines for the "fence" here were squeezed onto plastic and stripped off when dry. Then the pieces were adhered to the painting with gel medium.

Tin Foil Texture

Embossed aluminum foil can be painted and marked beautifully.

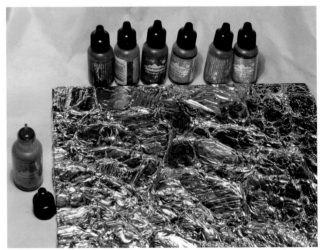

Cut a piece of foil large enough to cover one side of a piece of foam core (plus a little extra to wrap around the sides to the back). Use heavy duty or regular-weight foil. Crumple the foil very slightly, cover the foam core with it, and secure the edges to the back with masking tape. Form ridges, flat shapes, and patterns with your fingers or a rubber-tipped shaper tool. You can also bear down hard with a dull pencil to indent designs. Impress symbols, lines, and/or words if desired.

Paint the foil with alcohol inks or acrylics. Fill in depressions at different levels with deep puddles of paint for more variety.

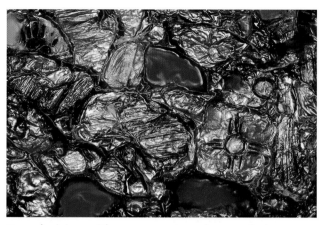

Try colorizing with permanent markers and glass or metal paints, too.

Painting Pointer

Use pre-moistened baby towelettes to clean acrylic paint off most surfaces before the paint dries.

Mystery Collage

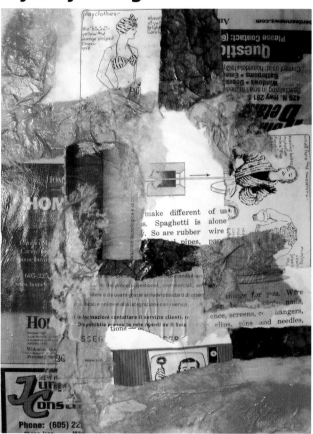

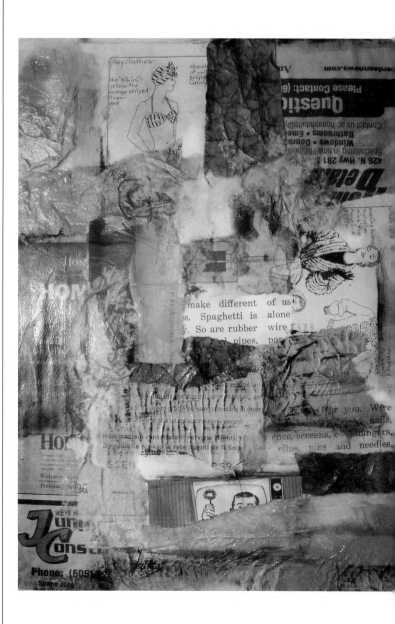

Save junk mail and other papers—old homework, bits of torn tissue or gift wrap, envelopes, and so on. Brush a layer of matte or gloss medium onto a sheet of waxed paper. Quickly tear the junk paper into small and larger pieces and randomly lay them face down onto the wet medium. Overlap the pieces and add more adhesive as needed. Then, after the collage is dry, peel it carefully off the waxed paper and flip it over to see what you have! Add marks and paint here and there as needed to help the artwork coalesce.

This Hinges on Two Canvases

Hinge two stretched canvases together to create a dimensional work with niches. The finished piece might be wall-hung or free-standing—your choice.

You'll need two canvases and hinges in appropriate sizes. First, paint the canvases, back and front. Collage, ink, texturize, and embellish them to your heart's content. Then attach the two parts with wood screws through the holes in the hinges.

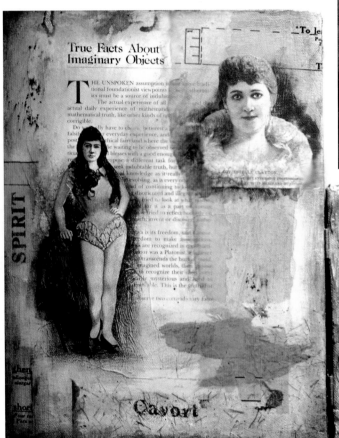

"The imaginative mind sees with the eyes of a bright angel."
—*Unknown*

In the Swim with Watercolor and Inks

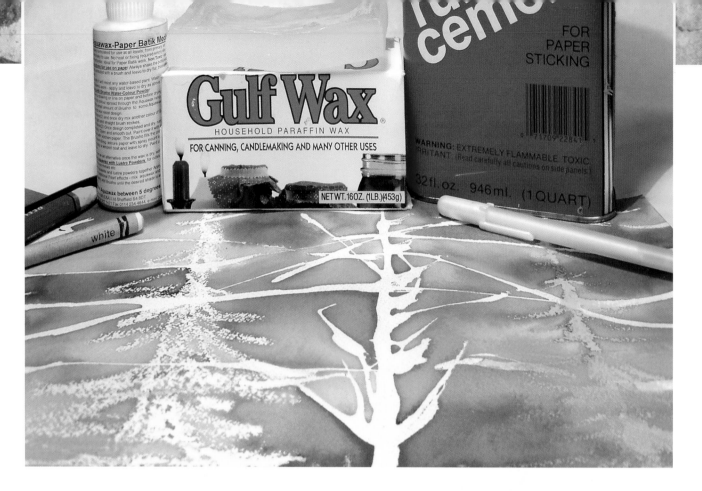

Go with the flow! Exploring watercolor paints (and inks) is an adventure, so relax and enjoy testing the waters.

Traditionally, transparent watercolor has been used in a light-to-dark approach, allowing the paper to provide the highest values.

Watercolor paints are available in semi-moist pans and half-pans, tubes, and concentrated liquid form. They are also found in pump-spray bottles. In addition, water-soluble pencils, markers, and crayons are plentiful.

Inks for art making run the gamut of drawing inks, acrylic inks, printing inks, stamp pad inks, India inks, sumi inks, calligraphy inks, and more. Some are opaque while others are transparent. Some are waterproof, others not. Application varies from brush or pens to airbrush.

WAXING THE BOARD

In the previous chapter, we used waxed paper as a resist material to retain highlights or light areas. Now we'll show you how other waxy media withstand watercolors (and some inks) beautifully.

Parents and grandparents: Save those crayon scribbles made by the youngsters you love! This watercolor landscape was done by a child named Maddy (with a little assistance from her grandma) over her colored wax scrawls.

Tools & Materials
- Wax crayons or paraffin
- Watercolor paper
- Brushes
- Watercolor paints or inks
- Rags and water containers
- Lithographic crayons, oil pastels, or china markers (optional)
- Aquawax, MicroGlaze, or Dorland's Wax Medium (optional)

Here's How

1. Buy paraffin in the canning section of the grocery, or use white or light-colored crayons. Even white candle wax will do. Any of these are likely to create a hard-edged effect with watercolor or thin, liquid inks, so you might want to use the technique in moderation.

2. Draw heavily with wax on either white watercolor paper or light areas of a dry painting. The marks will be difficult to see until they are overpainted. A wash (in a darker color) will reveal them. Generally the wax remains on the paper permanently.

3. Traditional oil pastels and oil sticks also repel paint. Other media that resist water-based paints include lithographic crayon and china markers. Finally, try MicroGlaze, Dorland's Wax Medium, Aquawax, and fabric wash-out products.

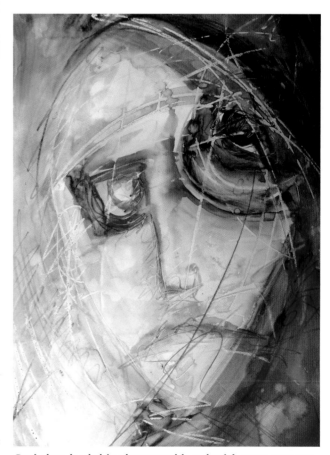

Geri sketched this abstracted head with wax crayons and then painted inks and watercolors over it.

While hot wax has its challenges as a resist product, it worked well here with water-based inks and watercolors.

Maskoid Marvels

Instead of wax resist, try rubber! Masking fluid is a resist material used to preserve highlights.

Always stir masking fluid well before using, and apply it to dry surfaces only. Avoid leaving it on the paper for long periods.

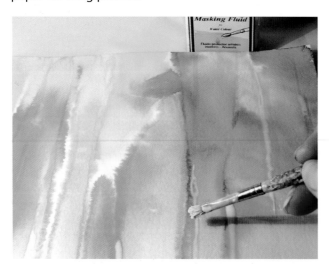

1. Apply the rubbery fluid by dribbling it onto white or light-colored areas, or by painting it on with an old brush. Wash the brush with soap and water immediately after use. You might try printing masking fluid on with a stamping tool.

2. Within minutes, you can gently brush over the masking fluid with thin paint. Don't scrub with the paintbrush.

Painting Pointer

An advisory about maskoids: Masking fluid usually contains natural rubber latex, which causes allergic reactions in some people.

3. When the wash is thoroughly dry, remove the masking material by rubbing or peeling it with your fingers.

The watercolor painting (and dried masking fluid) in this example was tinted with opaque inks. Once the inks were dry, the mask was removed.

Painting Really "Gels" with Resist

As you've seen in an earlier section about resists, acrylic media can be used to reserve white or light areas. Clear tar gel is pourable, with a stringy quality. Drizzle lines and shapes of it on dry watercolor paper to protect those areas, and let dry. The tar gel is permanent, preserving what is underneath it. (You can also use a fabric washout product as a resist on absorbent paper.)

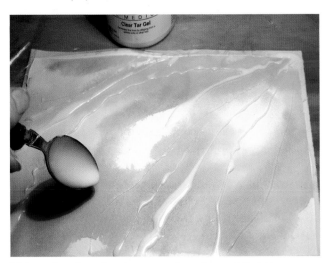

This resist piece begins on a dry piece of lightly painted Strathmore Imperial watercolor paper, but the tar gel could have been applied to white, unpainted paper as well.

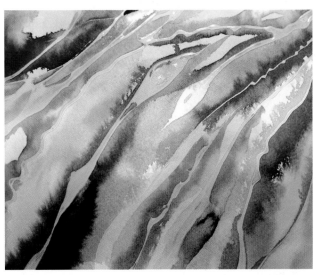

Once the tar gel is dry, wash over it or between the tar gel lines with watercolors or transparent liquid inks.

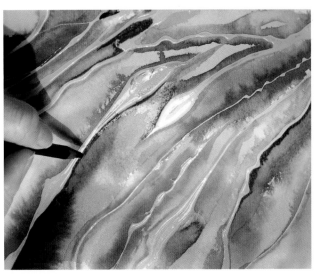

Here the piece was also enhanced with water-soluble pencils.

Savvy Substitution

Rubber cement can also function as a masking fluid, and it's less expensive. Sakura Glaze pens act as a resist, too. Draw or write slowly with them and let the glaze dry before washing over it.

BE A WRAP STAR

We've seen how well waxed paper performs as a resist. Now let's manipulate paint with it to create some creased and crinkly special effects! You can achieve comparable, excellent results with plastic sheeting, too.

Tools & Materials

- Watercolor paints and/or inks
- Watercolor paper
- Brushes
- Rags and water containers
- Waxed paper
- Sheet plastic or plastic cling wrap

Here's How

1. Cut a sheet of waxed paper slightly larger than the watercolor paper. Paint very wet, rich watercolors onto the watercolor paper and immediately press the waxed paper over the surface. Wrinkle it here and there to add interest and variety. A weight (like a book) on top may encourage even more patterning, but it's not necessary. Let dry overnight.

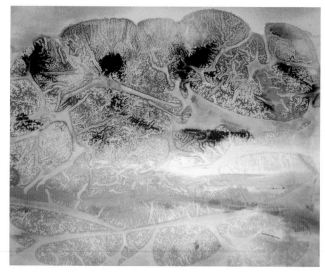

The foreground here could become more defined by creating edges or forms with another paint medium.

2. Instead of wrinkling it, you can also fold the waxed paper repeatedly, crease the folds sharply, and open it up again. Place it into the juicy paint and let dry without a weight on top.

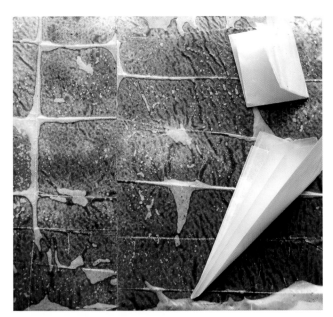

3. Peel off the waxed paper the following day. This example was then embellished with mulberry paper and opaque inks.

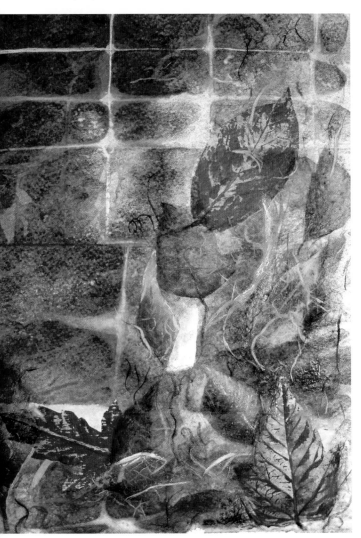

4. Plastic kitchen wrap functions somewhat similarly. Create a visually textured background or engage your imagination with the crinkly patterns.

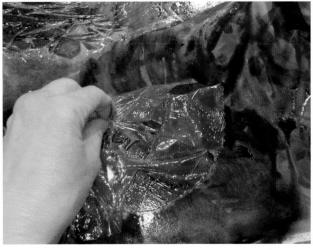

5. Cut a generous sheet of plastic wrap and spread it on wet paper that has just been painted with strong paint or ink. Pinch and grasp at the plastic until you are pleased with the results.

6. Let it dry that way and remove the plastic the next day. This illustration demonstrates the use of oil pastels to create a leaf on "ice."

These techniques can work with thinned liquid acrylic, too, although the waxed paper or plastic wrap should be removed before the acrylic completely dries. Otherwise they might stick to it.

NETTING THE CATCH OF THE DAY

Make a splash with gauze, cheesecloth, or other netlike fibers. Imprinting their patterns on paper is ingenious!

Tools & Materials

- Watercolor paints and/or inks
- Watercolor paper
- Brushes
- Rags and water containers
- Absorbent open-weave fabrics

Here's How

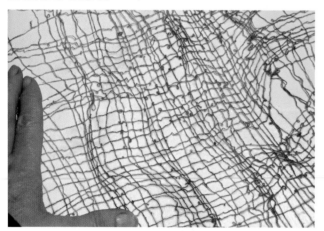

1. Use inexpensive, non-elastic cotton gauze for this watercolor texturizing technique. The loosely woven fabric will absorb the paint and leave its mark when lifted. Manipulate a single layer of the gauze with your fingers to make holes or an irregular pattern.

Another suitable material, used here, is the "freaky fabric" sold around Halloween. It's shown spread over wet paper that was previously protected (where white flower heads will be) with masking fluid.

2. Spritz the watercolor paper with clear water first to hold the fabric in place before paint is applied. Arrange the gauze on the wet surface.

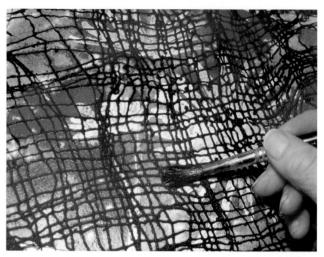

3. Apply saturated watercolor paint over the area with a large brush. Wait until the paper is thoroughly dry before removing the fabric.

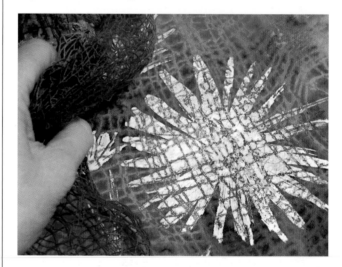

Green Scene

Clean, lidded baby-food and jelly jars always come in handy for holding water, paint, or small parts.

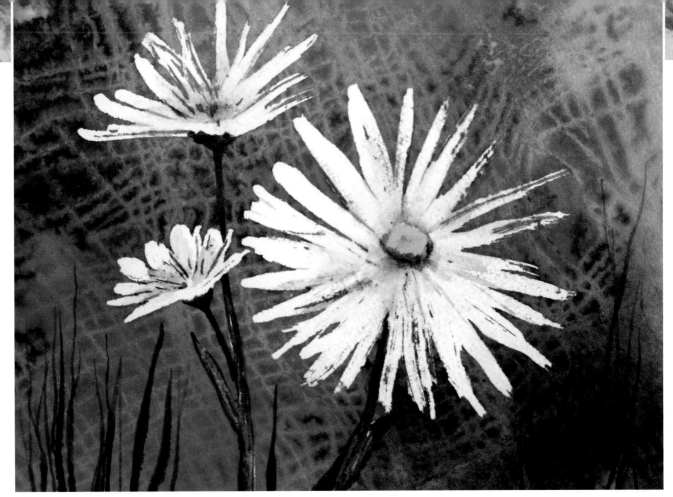

The result is reminiscent of fencing, basket weave, fishing nets, or spiderwebs. Now finished, this example was refined with fluid acrylic.

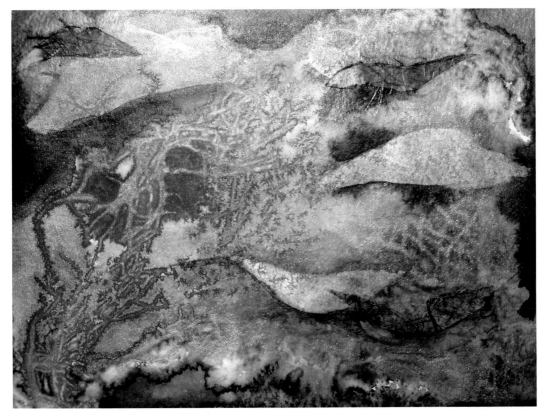

Evocative of an underwater scene, the watercolor piece pictured here was finished with rice paper and inks.

COMPELLING CONTOURS

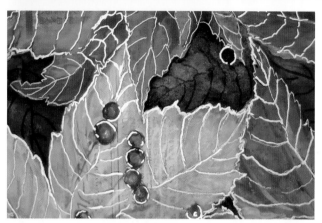

Changes in paint color, density, and value can create edges. Incorporate outlines to create an impressive, visually striking artwork.

Tools & Materials

- Watercolor paint and/or inks
- Watercolor paper
- Brushes
- Extra-fine pen or marker
- Water containers
- Rags
- Pencil (optional)

Here's How

1. Make a very light sketch or paint directly on the paper without drawing first. Wet the paper, mix colors of watercolor or ink, and apply washes with a brush. Be sure to create not only subtle, translucent areas but also intense color in places. Let dry completely.

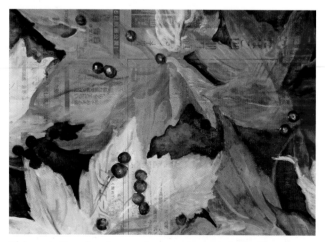

This painting has been done on newspaper. The translucence of watercolors allows the print to show through in places.

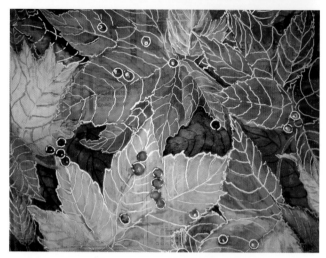

2. Where one color, tint, or shade borders another, an edge appears. Outline each and every shape with an extra-fine marker. We suggest a black pen or one in metallic silver, gold, or copper. The visual richness you achieve will be well worth your time.

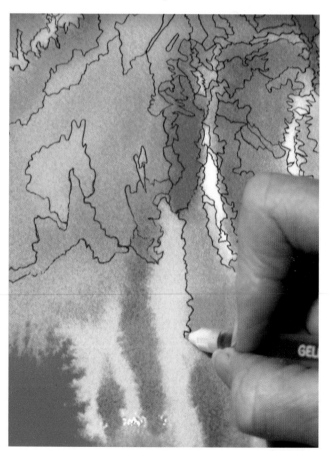

FLOAT YOUR BOAT FARTHER

Prepare to be inspired by these additional project plans. We hope they will energize you.

Layer Cake of Texture

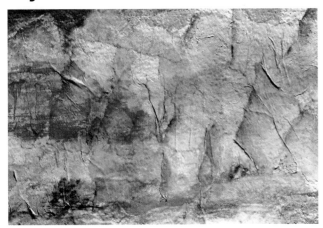

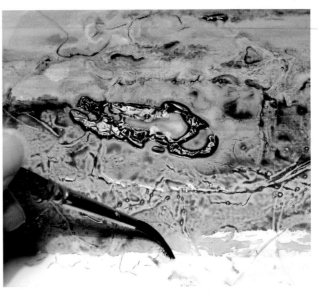

Here's an easy way to depict rocks, water, canyons, or other organic-looking areas: Build up layers in a number of media on a sturdy support and paint over them when they're dry.

First, lightly sketch basic shapes on the substrate. Then crumple rice paper and adhere it to some areas with liquid acrylic medium.

Roughly apply molding paste or gesso here and there. Drizzle strings of tar gel in places if you wish. Let dry.

Next, paint with thin watercolors to create shadows in the depressions where the paint settles. Paint will be lighter on the ridges.

Once the paint is dry, rub oil pastels over some areas, or add ink to further develop the painting.

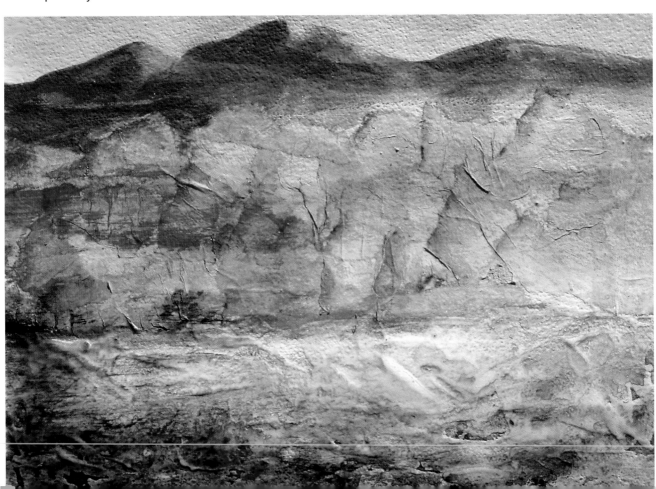

Do You Doodle?

Start with a drawing—done with permanent or water-based pencils, water-soluble crayons, ink, markers, or pens. Define shapes, forms, and edges.

Geri used pencil first to make this sketch. Then she added brown water-based marker lines and water-color paint.

A few touches of opaque gouache accent the piece (opaque ink would have worked, too).

This journal page was doodled and written on and then painted with watercolors.

Use Those Photo-Booth Prints

Colorize spare snapshots or photo booth shots with watercolors, Marshall's Oils, and water-based markers. Then cut them apart and arrange them on a sturdy support. When you're happy with the composition, glue the pieces down. Add lines or more painted areas if desired.

Here Geri used photocopies instead of actual photos, cut out and collaged with eyeglasses cut from a catalog. Next she added color with watercolor, colored pencils, and a few squiggles of metallic marker.

Slicing and Weaving

Take two watercolor paintings in different tones (one warm, one cool, perhaps). Cut them into strips that vary in width, and place them alternately beside each other in a pleasing arrangement. Discard any strips that don't enhance the composition. Adhere them to a background of choice: solid-colored or another watercolor painting.

You can also weave painted paper strips together!

First create a vertical "warp" with one painting, as shown at left in the photo.

Then weave in strips from the second painting (cut horizontally, to form the "weft") and glue them on the back.

A woven painting done with watercolors and water-based markers.

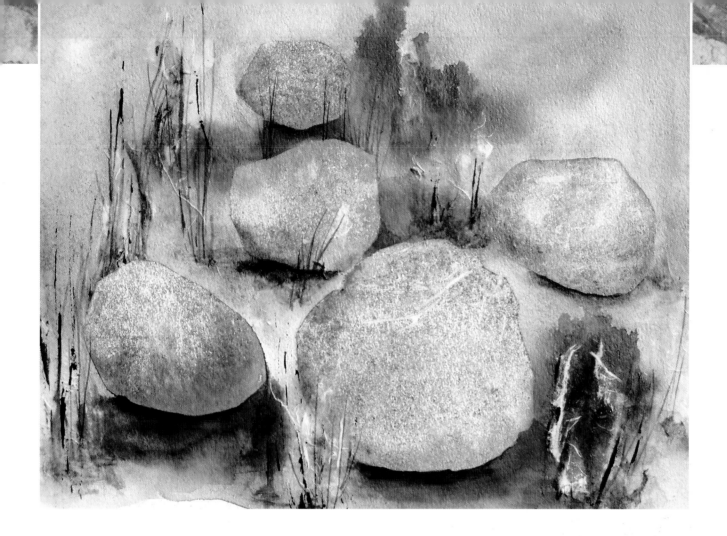

Shapes from Plastic Shopping Bags

So far, we've demonstrated ways in which waxed paper, cling wrap, and gauze could be used to imprint watercolor designs on paper. You can also print shapes with pieces cut from medium-weight plastic.

That's how the five boulders were created in this example, done on illustration board. (Rice paper and acrylic inks were added later.)

Cut shopping bag plastic into the desired shapes first. Paint juicy, wet watercolors on absorbent paper and immediately press the shapes into the paint. Let dry overnight before removing the plastic shapes.

Plexiglas shapes and shards of glass can be used in the same manner.

Blown Away

Blow branching lines of ink or watercolor onto watercolor paper and you'll be left with lots of exciting negative space—the blank spaces of white paper. If you want to paint solid shapes inside those areas, we'll show you two ways to enhance them even more.

To blow organic lines, first place a drop of ink or intense watercolor on the paper. Blow through a drinking straw, wiggling it as you follow the droplet around the page. Blow more lines in different directions, going right off the edge of the paper. Let dry.

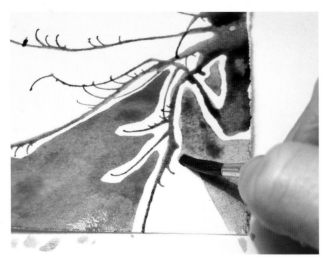

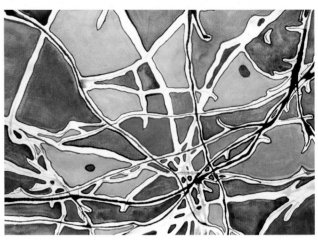

Leave a white margin around the branching lines as you fill in the empty spaces with watercolors and a brush.

After the paint is dry, outline the filled-in shapes with fine markers. Glaze pens were used here.

You can also highlight and shade the shapes with soft pastels.

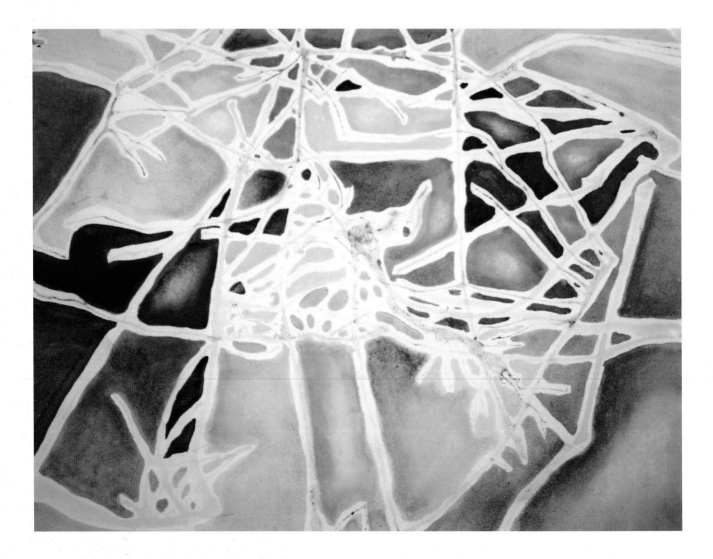

"Creativity is originality,
ingenuity, and inventiveness.
It is resourcefulness and vision."
—*Unknown*

**Plunge into
Oil Paints**

FOUR

FOUR

Today's oil paints are better than ever, and affordable, too! Besides conventional oils, you can buy water-mixable formulas that do not require solvents and alkyd oils (synthetic oil polymer paints), which dry faster.

Oil paints even come in markers these days, as well as oil bars and paint sticks.

You'll need a solvent to thin traditional oil paints and clean your brushes. Turpentine and paint thinners are noxious and strong-smelling. Non-toxic alternatives to conventional solvents are specially formulated to be safer. Tighten the lid on a bottle of solvent when you're not painting and keep it away from children. Don't expose oil painting materials to a heat source.

Tools & Materials

- Oil and acrylic paints
- Odorless solvent (unless using water-mixable oils)
- Brushes, including a wide one (1 to 2 inches)
- Soft pastels (or oil pastels or watercolors)
- Newspapers
- Black foam core

- Paint shaper or other scratching tool
- Rags
- Small scraps of matboard
- Magazine images or other collage papers
- Canvas or other sturdy substrate (optional)

Green Scene

Dispose of excess solvents responsibly. Take them to a recycling center.

GETTING YOUR FEET WET

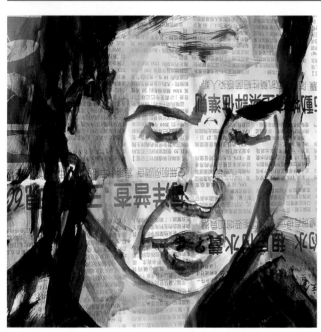

Let's dip into oils with a warm-up project first, using newspaper as a substrate.

Here's How

1. Double or triple the newspaper sheets, since oil will seep through to the back. (Geri uses a glue stick to attach newsprint to a large piece of matboard.)

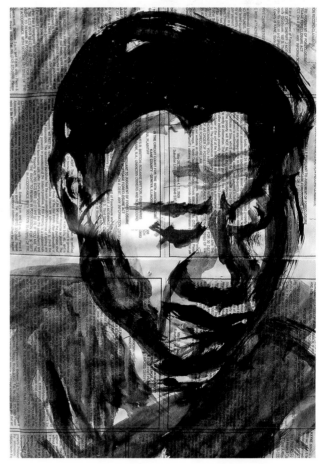

Without a sketch, simply dip a wide brush into lightly thinned black oil paint and use broad strokes to suggest your subject on the newspaper. Don't worry about fine details.

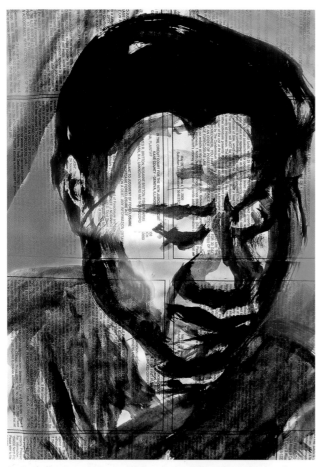

2. Let dry, and then add color with soft pastel, oil pastel, or watercolors.

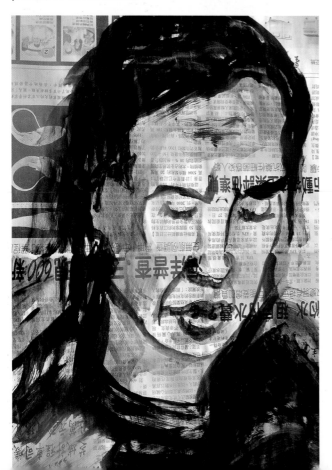

Geri took the idea further by creating a newspaper collage to use as a background. Clear acrylic gesso sealed the collage.

She began with a small sketch of a landscape.

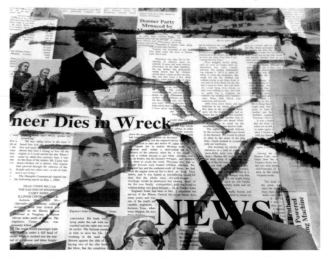

Burnt sienna oil paint was brushed on to define shapes.

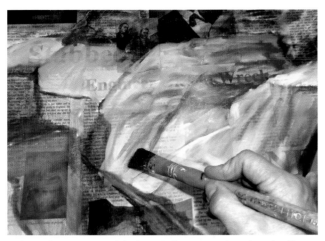

Oil washes were added and then mostly wiped off.

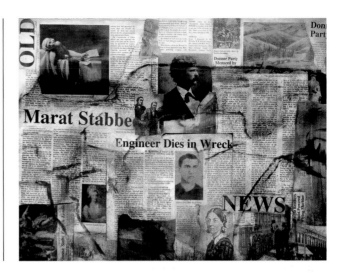

SCRATCH AND REVEAL

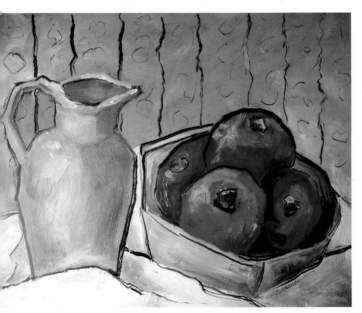

Black contour lines can impart a pleasing stained glass effect. Apply a layer of wet oil paint to a black background and scratch through it to create a line drawing, revealing the color underneath. *Sgraffito* is the art term for this technique.

Here's How

1. Select a piece of black foam core to use as a base. The shinier, coated kind is best, but you can use the matte type if you mix linseed oil into the oil paint to make it very juicy (because oils alone dry quickly on matte foam core). Paint a design or subject matter of choice with oils onto the black surface. Use enough paint to cover the entire piece of foam core.

Painting Pointer

To hold the foam core in place while working on it, pierce both sides with long ball-tip sewing pins. You can lift the piece off later without getting paint on your hands.

2. While the paint is still wet, draw into it with a brush handle or a silicone- or rubber-tipped paint shaper.

Carve into the paint to reveal the black support. If you make a mistake, just smooth out the oil paint and scratch away again. As soon as you're satisfied with the sgraffito, let the piece dry for a few days, depending on the thickness of the oil paint.

3. Oil pastels can be used over dry oil paints to accent the finished artwork.

"Alluvial," by Geri: oils over acrylics and other media (corrugated cardboard, tissue, and packing fiber).

"Language of Art," by Geri: oils over acrylics.

OILS OVER ACRYLICS

You can successfully apply oil paint over (dry) acrylic paint and other acrylic media. (Doing the reverse, acrylics over oils, is not recommended.) The texture in this detail was achieved with gel medium. After it was dry, oils were painted over it.

In this example, a few oil pastel accents were added after the oil paint was dry.

Beneath the Surface

Play hide and seek with scraped-on paint!

Here's How

1. Squeeze out various colors of acrylic paint onto a palette. Grab a piece of stiff cardboard or matboard about 2½ inches long and 1½ inches wide and use it as a tool with which to randomly swipe the paint onto a canvas. Leave some of the white canvas showing in places. Let dry.

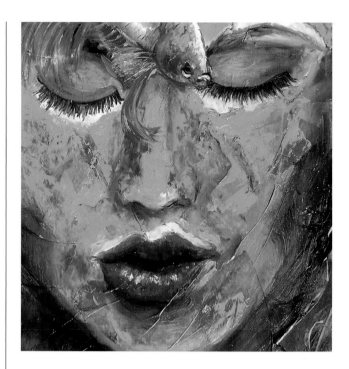

2. Study the accidental acrylic shapes and use your imagination to find your subject matter in them. Does one smear remind you of a mountain? Do you see an animal's ear? Bring the vision to life with oil paints and brushes!

AMAZIN' GLAZIN'

Drawn and painted on a humble surface, this project is likely to have a stunning jewel-tone finish. Glazing creates rich, luminous color. It requires the building up of thin, transparent layers of paint.

Tools & Materials

- Heavy brown paper
- Painter's tape
- Drawing board
- White gesso
- Graphite pencil or graphite transfer paper
- Clear acrylic spray
- Oil paints
- Liquin or other solvent
- Cotton swabs, cotton balls
- Rags
- Palette and palette knife
- Soft, flat oil/acrylic paintbrush

Here's How

1. Cut heavy brown paper to the size desired. Tape it to a drawing board or other (protected) surface. Paint a coat of acrylic gesso onto the brown paper. If one coat is streaky, add another after the first is dry.

2. When the gesso is dry, sketch directly onto it or transfer a sketch using graphite paper. Avoid erasures, since they might "dirty" the painting. Select a subject (portrait, still life, landscape, or other) that exhibits strong lights and darks. Subject matter with good contrast helps assure success.

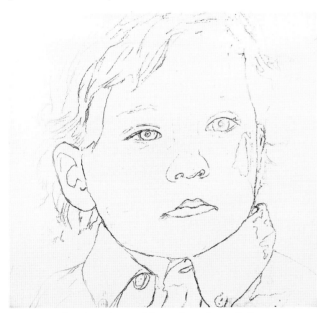

3. Spray the drawing with Krylon Crystal Clear or other fixative to prevent smudging.

Painting Pointer

Always spray aerosols in a well-ventilated area or outdoors. And when you're working with solvents, wear protective gloves.

4. Mix cadmium yellow oil paint (medium or light cadmium yellow) about 40/60 with Liquin on a palette. Make a good substitute for Liquin by combining stand oil (or linseed oil) with mineral spirits (or turpentine), 40 percent and 60 percent respectively. Use the brush to paint the entire substrate with the first glaze.

5. Lift out highlights wherever needed, dabbing with a rag or cotton balls. Use cotton swabs for tight areas. After the light areas have been picked up, allow the painting to dry before proceeding. Always let the paint dry before adding a new layer of glaze, to prevent the colors from muddying.

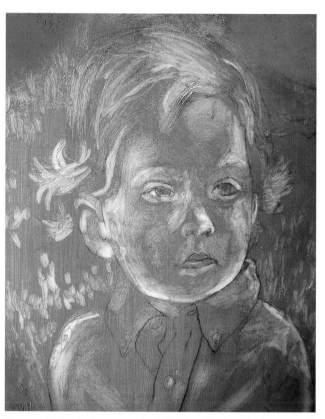

6. Next, mix alizarin crimson (or permanent rose) oil paint about 50/50 with Liquin to create a red glaze. (This color, like the blue to come, is less opaque to begin with.) Test the mixture's translucence on scrap matboard. If it's suitably thin, paint it over the whole painting. Some parts will turn orangey because this layer, like a colored lens in eyeglasses, visually mixes with the yellow. Lift out all the highlighted areas again—and any sections that you want to be yellow as well.

Areas that will be very dark in the final painting need not be lifted out. Mix things up a bit and save the red layer for last if you like. Rules are made to be broken!

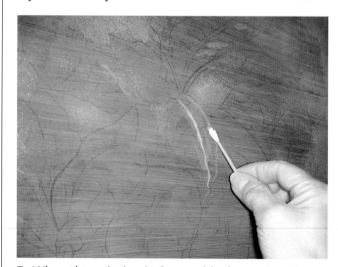

7. When the painting is thoroughly dry again, mix a dark blue oil glaze of ultramarine blue (or pthalo blue) with an equal amount of Liquin. Apply to the entire painting, and start lifting out all the lighter bits again. Wipe less vigorously wherever you want middle values.

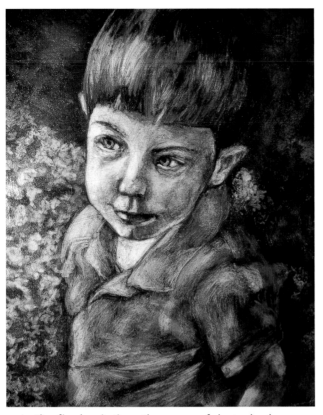

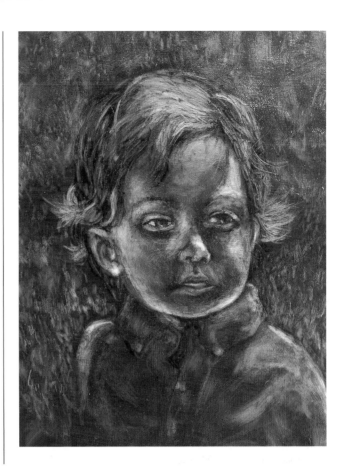

In the final painting, the areas of deep shadow are composed of all three glazes.

MAKING A MONOPRINT

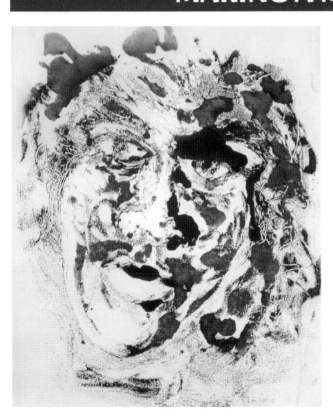

A monoprint produces only one print, making each one unique. Since it's a process that relies heavily on experimentation, results will vary from print to print.

Tools & Materials

- Oil paint
- Brayer (paint roller)
- Palette knife, shaper tool, or stiff brush
- White paper
- Large pane of plexiglas or heavy plate glass
- Rags
- Your choice of oil pastels, soft pastels, or watercolors
- Solvent
- Baren or large wooden spoon (optional)

Here's How

1. Place white paper under the plexiglas on your work surface, the better to see your image as you create.

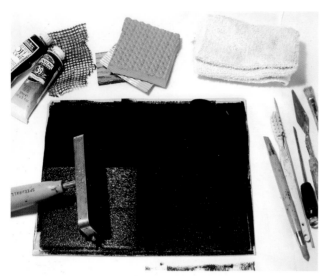

2. Roll a dark color of oil paint onto the plexiglas. You can cover it completely or choose to leave select areas clear. You can also use more than one color of paint if desired. White and light-colored oils on the printing plate would produce a good print on dark paper.

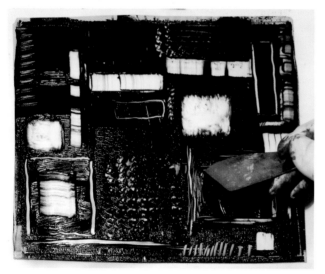

3. Draw and scratch into the paint to leave marks and create patterns. Wipe off areas of paint as needed to make highlights, or press textured materials into the paint, partially lifting it. Experiment with techniques and styles. If necessary, add more paint to unsuccessful areas and change them. The paint will stay wet and printable long enough for you to work for some time on your image before pulling your final print.

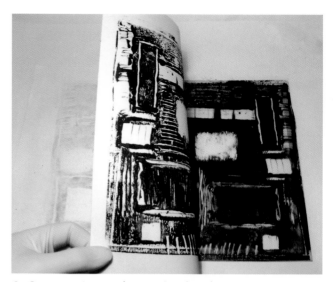

4. Once you're ready to print, lay the paper onto the inked plexiglas. We used dry white drawing paper for our prints. Apply pressure all over the back of the paper with a baren (a hand tool used to burnish the paper), the back of a wooden spoon, or the palm of your hand. Peel the print off and hang it or set it aside to dry overnight.

(Remember when we said each monoprint is one of a kind? Sometimes you can pull a second, "ghost" print of the remaining oil paint on the plate.)

At the end of the session, clean the brayer, plexiglas, and tools with solvent, soap, and water.

After the print is dry, in about a day, you can embellish the print with added color—oil pastels, here—if desired.

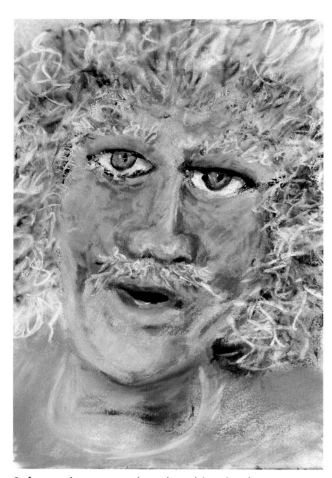

Soft pastels were used to alter this print, but water-colors also work well.

Notice the voids left on the pulled print at the top in the photo. The used printing plate is below it, with paper shapes still in place.

Another monoprinting option is to cut out silhouettes from paper (flat shapes) and lay them onto the oil paint before pulling a print. They serve as masks, keeping the paint underneath them from printing. Red and brown oils were first applied to the plexiglas with a stiff brush.

SLIPPIN' AND SLIDIN'

Things will go swimmingly if you slick up your substrate. Oils really move and glide on the surface after this treatment.

Here's How

1. Buy plain, unflavored gelatin at the grocer's. Add one envelope of gelatin to one cup cold water in a saucepan and bring to boil as you stir. Remove from heat and cool. The mixture's consistency should be about that of honey.

2. Brush it on your substrate of choice. Illustration board or sturdy, smooth paper is best. Let dry overnight.

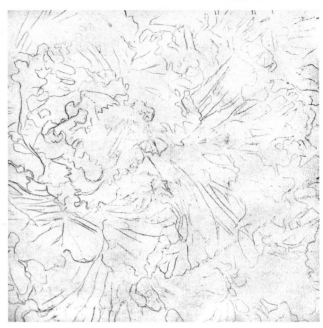

3. Sketch with pencil if desired.

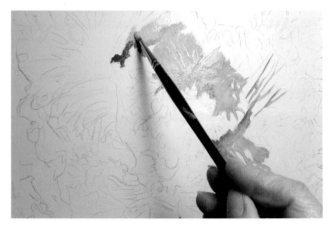

4. Paint with "lean" oils first (thinner color) and use thicker paint later.

Green Scene

Use the laser side of junk mail CDs as mini paint palettes. They have a finger hole built right in to hold! Colors mix well on the surface and wipe off easily. Old ice cube trays are great, too, for mixing paints in the compartments.

"My Pretty Little Vegetable," by Geri. Heavy foam-core board with tube watercolors.

FLOAT YOUR BOAT FARTHER

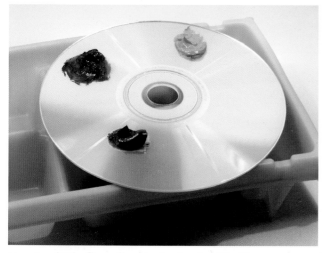

Here's a little flash flood of mixed-with-oils motivation.

Metallic Magic

Instead of scratching through to the black foam core we mentioned earlier in this chapter, try painting oils over a piece of matboard that's been sealed with liquid acrylic gloss medium. Wait until the medium is dry before covering with oil paint.

This scratched-through example was done on muted metallic gold matboard.

Another idea is to paint oils on an aluminum or copper sheet and scratch down to the metal.

In the photo below, the copper highlights are most evident at upper left.

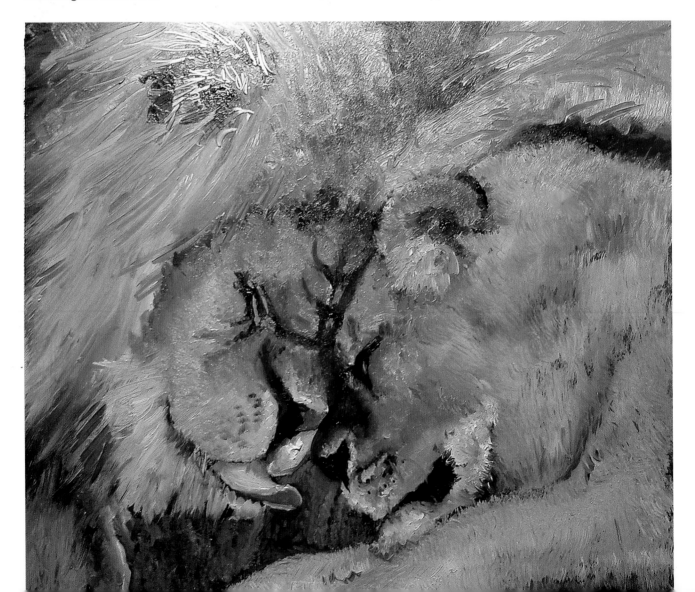

Turn That Frown Upside Down

Just as you used your imagination with the Beneath the Surface project, so can you do the same to rescue a canvas. Next time you find yourself lost at sea with a painting that's going nowhere, try this: Turn it downside up and squint. What do you see? With your mind's eye, find shapes and forms to develop into a brand new artwork!

Use art media that are compatible with the existing paint to elaborate on the new subject or theme.

Roughin' It

The coarse texture and irregular grain of burlap make it an interesting fabric to paint on. They impart a tapestrylike appearance to the work. Ampersand makes a number of products you can attach burlap to.

Choose from a variety of burlap weaves and colors. Attach it to a board or canvas panel with glue. Once the fabric is thoroughly dry, you can gesso it if you wish. After the gesso is dry, paint with old brushes, since the rough texture is hard on them.

Gotcha Covered

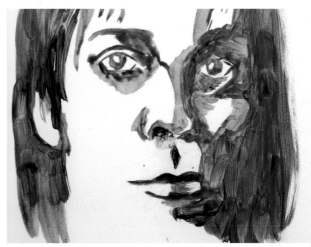

Is all the whiteness of a brand new canvas a bit intimidating? Fear not. *Imprimatura* is a technique that involves staining or toning that glaring white surface. You can sketch on the canvas beforehand or after the tint is dry.

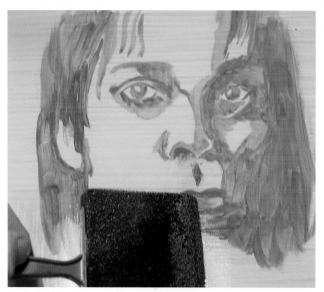

The drawing in our example was done with thinned acrylic paint in an earth tone. Once that was dry, a transparent wash of golden ochre acrylic was applied with a large foam brush. Thinned oil paint can be used for imprimatura instead, of course.

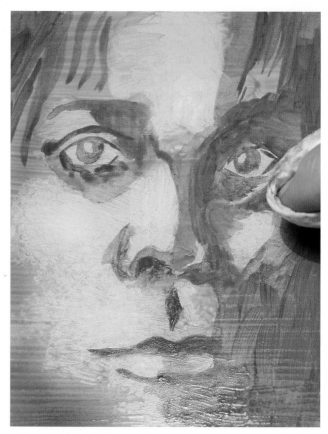

Wipe out highlights with a rag or paper towel if you wish.

Let the subject matter dictate your choice of color for the tint. Always allow the tint or stain to dry before painting over it. Toning the canvas adds unity to a painting.

Into the Pool with Pastels

Both oil and soft chalk pastels are direct and straightforward art media. No brushes or thinners are required. They are available in artist-quality selections or less expensive sets. Their vibrant colors are a joy to use.

Often thought to be drawing tools, pastels truly are painting materials. Just look at the popularity of water-soluble oil pastels!

Usually found in boxed sets of round or square sticks, soft pastels also can be purchased individually or in generous pans (pan pastels are pictured). Although high-quality soft pastels are fragile and break easily, they are a pleasure to use.

Shown on page 70 are Conté pencils and hard pastels. The former are handy, especially since they offer more control. Conté pencils are easy to transport for use in a sketchbook.

Oil pastels are vivid, luminous, and somewhat translucent. Student-grade sets such as these are good for beginners.

Finished oil pastel paintings do not require a sealant such as is often recommended for soft pastel paintings.

Hard pastels aren't as buttery as soft ones but they work well for sketching and fine detail work.

Blending stumps are usually tapered at the ends. Cleaning them usually involves removing the dirty outer layer by rubbing the implement on an abrasive surface such as sandpaper or an emery board.

Pastelbord by Ampersand is available in several colors.

Painting Pointer

You produce dust as you work with soft pastels. Be sure to use an air purifier to limit what gets released into the atmosphere. You can also wear a protective face mask.

Tools & Materials

- Oil pastels, both traditional and water soluble
- Soft pastels
- Substrate of choice
- Brushes
- Rags
- Kneaded eraser (also called a putty eraser)
- Blending stumps or tortillons
- Sandpaper
- Fixative
- Watercolors, water-soluble pastels, gel pens, tempera, inks, acrylics, oils
- Charcoal
- Liquin or other solvent
- White gesso
- Conté pencils

TOWARD THE LIGHT

Here we'll show a progression from a dark drawing (done in low values) to a painting with higher values of oil pastel. And in a second demonstration, we'll go from dark to light with soft pastels.

Here's How

1. Draw a sketch with soft charcoal (charcoal pencil, vine charcoal, or compressed stick). Vine charcoal is an art product that is made by burning twigs or wooden sticks. Like charcoal pencils and compressed charcoal sticks, it is available in soft, medium, and hard consistencies.

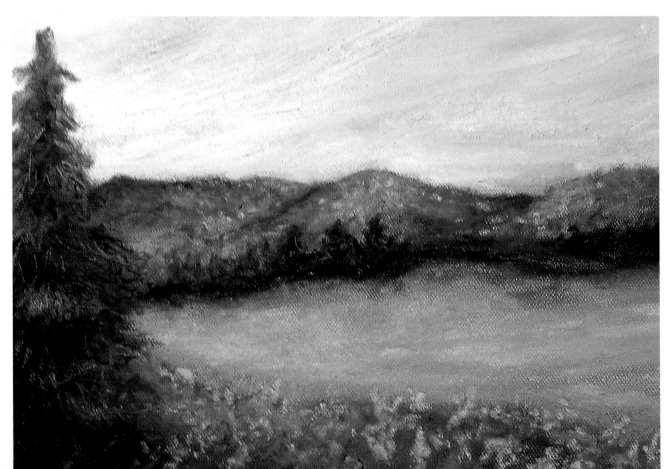

2. Pour a small amount of Liquin or Turpenoid into a glass, ceramic, or metal container. Dip a bristle brush into it and "paint" the charcoal, creating many values from pale and medium grays to black. Leave some of the white paper or board showing, too. After the solvent is dry, lightly mist the entire surface with clear acrylic spray to prevent it from dirtying the color to come.

4. Blend the oil pastels with fingers, a rag, even a bit of Liquin if you wish. Then add some sharp details here and there to finish the painting.

3. When the protective spray is dry, begin adding medium and light colors of oil pastel.

Instead of oil pastel, Geri used soft pastels as the finishing touch on this charcoal drawing. Before adding color, she sprayed the piece with fixative so the charcoal wouldn't smear. She entitled it "On-Line Conversation."

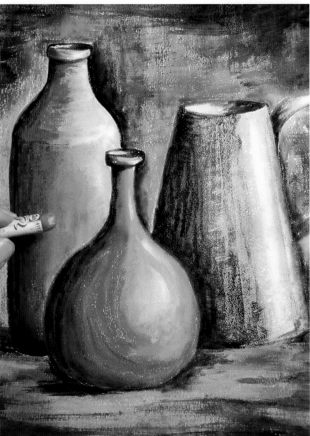

When the ink is dry, add mid and light tones with soft pastel or Conté or pastel pencils. Blend with cotton swabs in tight spots.

Another option is to draw or paint first with India ink or any dark, waterproof ink. The black drawing here is done with India ink; the brown example is done in shellac-based ink.

Geri created this portrait in a slightly different manner, using black, gray, and white Prismacolor pencils first. She painted over them with oil pastels afterward.

Savvy Substitution

If you have leftover matboard scraps, the colored sides make great surfaces for oil or chalk pastel. Is your wallet smiling yet?

PAINT IT BLACK

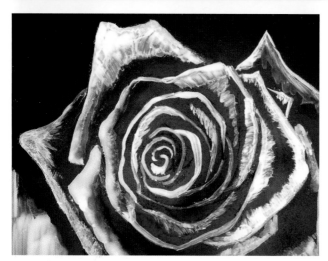

Instead of working from dark to light, try the opposite!

Here's How

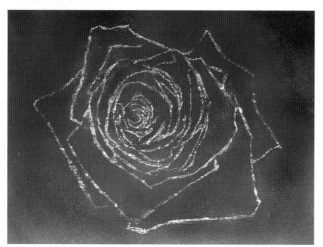

1. Begin with a dark surface or create one yourself. Paint the canvas or paper with permanent ink or acrylics in black or any dark color.

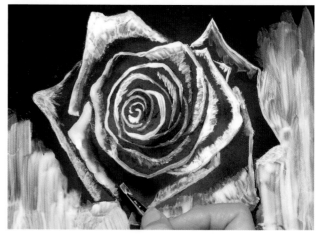

2. When that's dry, draw or paint in the subject using white: white gesso, paint, ink, gouache, or pastels. Think in reverse, sketching in just the highlighted areas and important edges first. Here we outlined the rose with white chalk, and then painted in the highlights with gesso. Let dry if you used a white liquid.

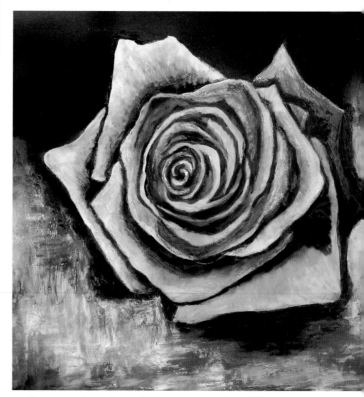

3. Next, work in the middle tones with a different medium (oil pastels were used on the rose). The dark background provides the shadows.

FLOODING IT

As we've said earlier in the book, you can use oil pastel first and add washes over it that are resisted (thin gouache or tempera, watercolor, watery liquid acrylic, or drawing inks).

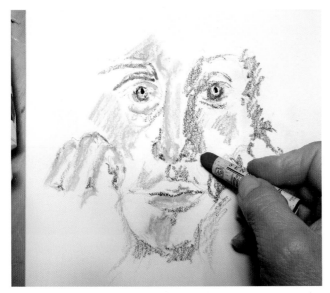

Here, Geri sketched with oil pastel on watercolor paper.

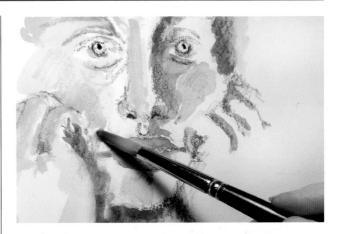

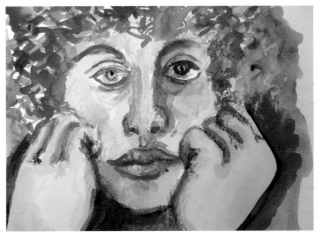

She used colored inks and Golden's liquid acrylics, thinned, over her sketch.

BUILDING FROM THE GROUND UP

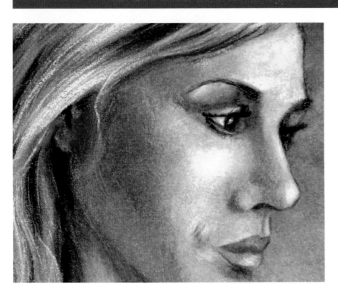

Light the way with this soft pastel project. Although the demonstration is done with a portrait, the method works with figures, still lifes, landscapes, animals, or any other subject matter.

Savvy Substitution

Use white gouache if you're out of gesso.

Here's How

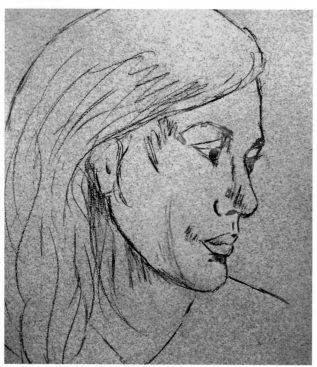

1. Select medium gray, tan, buff, or blue paper for pastels. Sketch lightly with a pencil or a neutral color of pastel. (The paper used here is 60-pound tinted pastel paper.)

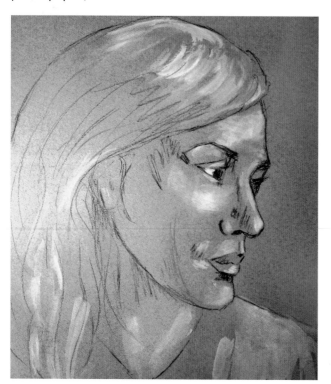

2. In a shallow container, dilute white gesso with water. Brush it onto the paper wherever you need highlights. Use a clean, damp brush to feather the edges, blending them out.

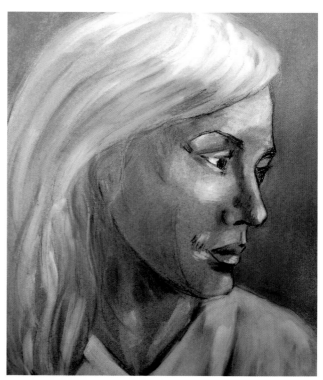

3. When the paper is dry, begin adding middle values of soft pastels. Lightly place medium colors—those that are not too white or too dark. Notice here that the background has been blocked in, too. Payne's gray was used on the face, and yellows in the hair.

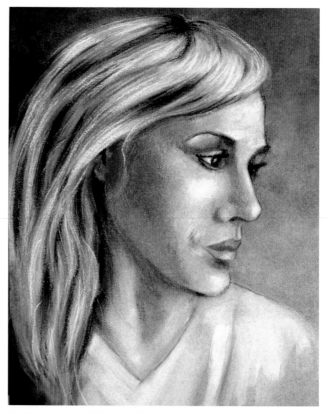

4. Continue with middle and dark tones, saving strong highlights for last.

ROCK THE BOAT WITH ACRYLICS

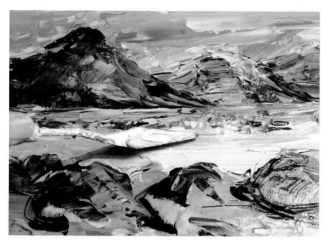

We'll show you three ways to use acrylics with pastels—both oil and soft pastels. The first method involves somewhat thick acrylic paint.

Here's How

1. Use heavy-bodied acrylic paint or mix acrylic paint with light molding paste or heavy gel medium to thicken the paint. Paint the subject you have chosen onto any substrate —even glass or plexiglas (we used Roc-lon, an art fabric, because its flexibility was an asset). Apply the paint heavily with a stiff brush or painting knife. The thicker the paint, the more pronounced the peaks will be.

2. Before the paint can dry, press a sheet of paper (or Roc-lon fabric) onto it. Press all over the back with your hand to ensure good contact. Peel the page off and set it aside to dry overnight. It will be a mirror image of the original.

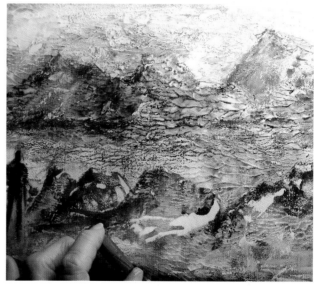

3. The next day, peel the wrappers from oil pastels in colors that contrast with the painting. Hold the pastel sticks broadside (parallel to the paper) and rub them over the ridges to accentuate them.

Acrylic Paint OVER a Soft Pastel Painting

1. This nonobjective artwork was done on toned pastel board. Paula thought it needed more work, so she mixed liquid acrylic paint with water in a jar.

2. She propped the art up at a sloping angle and poured drips here and there to add contrast and emphasis to the work.

Let's Accent a Painting with Soft Pastels

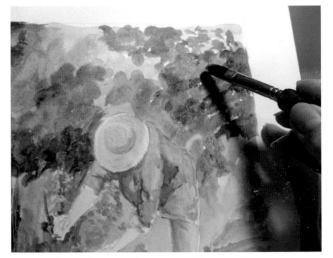

Thinned acrylic paint has very different characteristics from pastels, and they contrast well. Here, we'll combine washes with the opacity and texture of soft pastels.

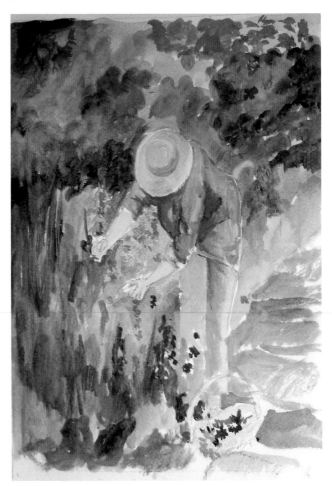

1. Select watercolor paper for maximum effect. Create an underpainting with diluted acrylic paint. Let dry.

2. Enhance the painting with soft pastels, beginning with broad strokes in larger areas. Light colors are especially effective over a dark background.

3. Finish with some defined edges and finer details on the important elements. Make them with sharp corners of pastels, or with the tips of pastel pencils. Leave other areas in soft focus for contrast. Spray lightly with fixative when the artwork is done.

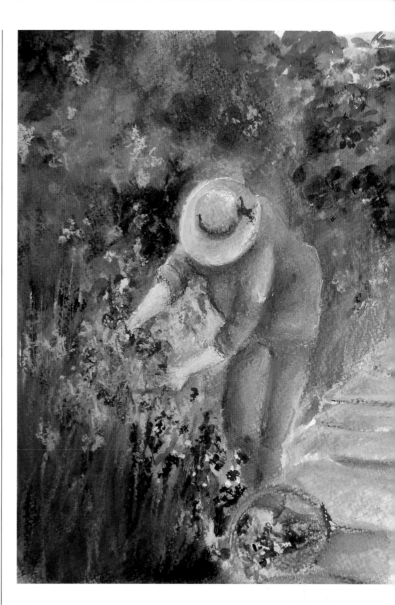

You can substitute watercolor paints for acrylics, of course. In this example, Geri has sketched seashells with gel pens and watercolored over them. An Asian newspaper is her paper of choice, creating an interesting background.

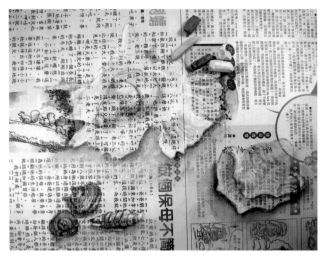

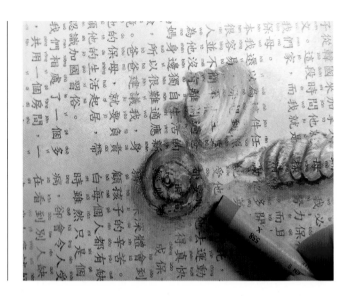

Soft pastels come next.

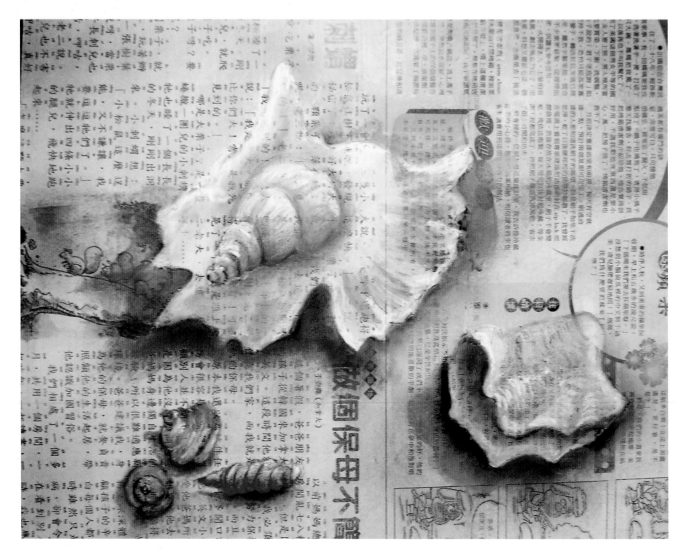

FLOAT YOUR BOAT FARTHER

Flaunt your creative license with pastels and try these supplementary ventures.

Glue Factory

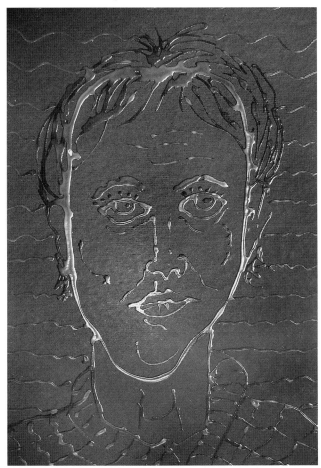

Squeeze bottles of craft glue make great drawing tools. Try a continuous-line design with glue—a figure in motion, a graceful animal, flowers, tree branches, or birds in flight, perhaps—and let it dry. This face was "drawn" on heavy black paper. A design in the background adds interest.

Add soft pastels.

The lines in the background were enhanced with a metallic gel pen.

This piece was painted with gouache on watercolor paper.

Accents of soft pastel were added once the paint was dry.

Oil Over Oil

Oil pastel is very compatible with oil paint. It can contribute linear and granular qualities that are different from those achieved with paint brushes.

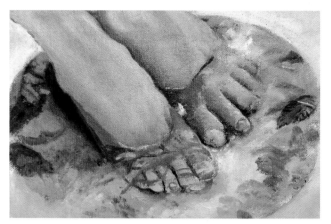

Geri thought the water could appear more reflective in this finished oil painting.

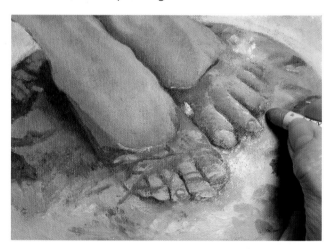

So she used iridescent oil pastels on it and blended them with a brush and Turpenoid.

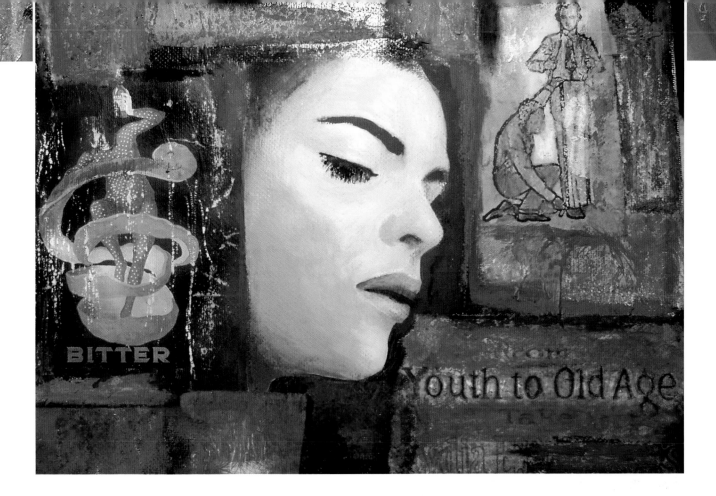

Weather (or Not)

Ever have the urge to just rip and tear something? Try aging an artwork, or a part of it, to increase interest. We aren't suggesting that you slash and destroy the entire piece. Wrinkle, crease, burn, or deliberately stain the paper only here and there. Sandpaper parts of an artwork. The bitters ad at the left side of the collage/painting pictured above was scratched and sanded. Or use tape to lift off a thin layer of paper or paint. (Don't use all of these techniques on one piece, please! One or two are plenty.)

Planning to use this old book page in a mixed media work, Paula altered it with alcohol ink stains and soft pastel color. Then she lifted masking tape after having burnished it down. See the layer of paper she's peeling off?

Painting Pointer

If you prefer, use rubber gloves when you're handling oil pastels. Otherwise, pop-up wipes or moistened towelettes do a great job of cleaning the hands.

Both of the authors often pick up rusty bits and interesting found objects along roadsides or sidewalks to use in their art. Here, Geri is using some of hers in a piece with modeling paste, skeletonized leaves, wire mesh, and more.

She finished the artwork with various paints and oil pastel accents.

Frottage

This art technique involves making a rubbing over a textured surface. Oil pastels lend themselves well to the process.

Choose tissue paper, rice paper, or any fairly thin paper. Select oil pastel colors that will contrast well with the paper color. Peel the paper wrappers from the pastels.

Find flat, textured items to lay the paper on, and hold the paper in place with one hand. Run the pastel broadside over the paper to "capture" the pattern.

Use the papers in a collage/painting. This one includes, besides frottage papers, other papers and acrylics.

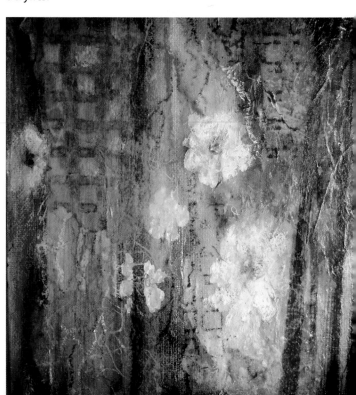

Scumble, Stipple, and Scrape

Dotting, rubbing, jabbing, and scuffing sound fun, right? They are, and easy, too.

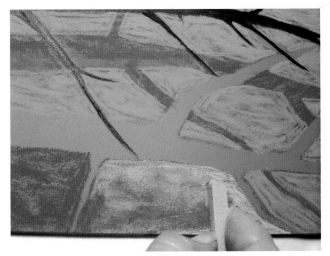

Scumbling, in which a lightly applied new layer only partially covers the one below, can be done with either soft or oil pastels. It allows bits of the paper or the color underneath to show through in small patches.

Hold the pastel stick broadside and stroke gently.

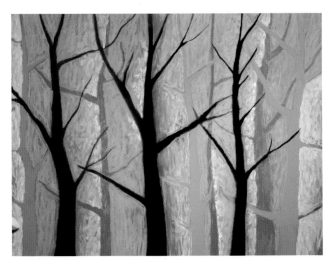

Stippling, too, can be done with any type of pastels. This method entails the application of dots of color, small dabs of unblended colors beside each other. It's an Impressionistic technique because, from a distance, the eye mixes the specks to form a unified surface.

Leave marks on the paper or other substrate by jabbing the tip of the pastel stick on the surface. Don't smear or smudge them together.

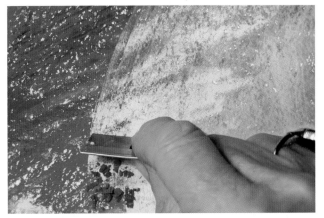

If a thick layer of oil pastels becomes muddy or otherwise problematical, it can be scraped off with a single-edged razor blade or an old credit card. Some artists graze oil pastels off just because they like the lighter-colored result!

Geri applied oil pastels heavily to Claybord and scratched through the layers with a sharp tool to make this artwork.

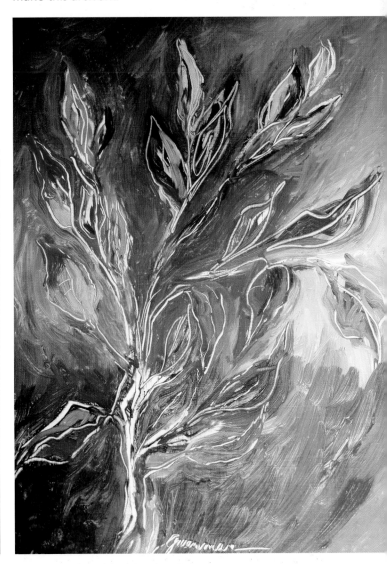

Just Add Water!

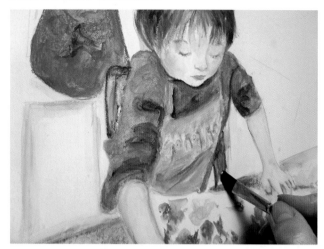

While many artists use paintbrushes to blend or flick away excess *dry* pastels, here's a moist method that produces a painterly effect. Wet-brushing smoothes out any graininess and lends a velvety effect to the painting.

Just dip a brush into clean water and blend the dry colors that were previously applied to the paper. Keep several clean brushes handy and switch them as needed.

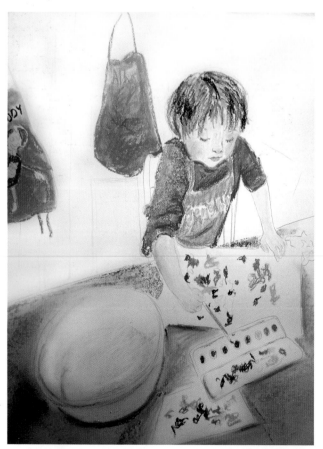

Here's the soft pastel painting before wet-brushing was done.

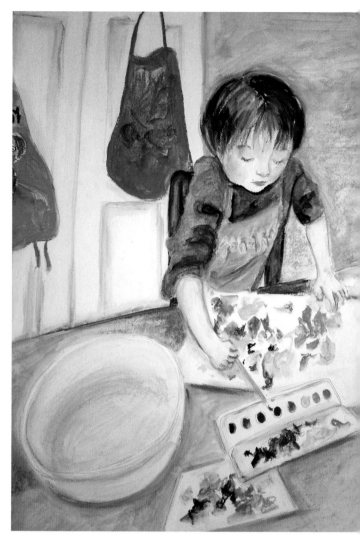

Here it is afterward.

Awash in Creativity

Water-soluble pastels perform much the same way as regular oil pastels until water is added to the equation. They "melt" easily when dipped into water or brushed with water, or when they are drawn onto a wet surface. The colors are luscious! Even wax crayons come in a water-soluble formula.

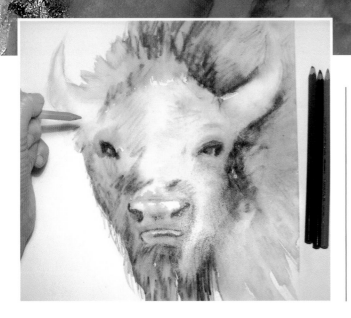

Similarly, a water-soluble pencil sketch softens and blends when you brush over it with water.

This bison was finished with soft pastels once the watercolor paper was dry.

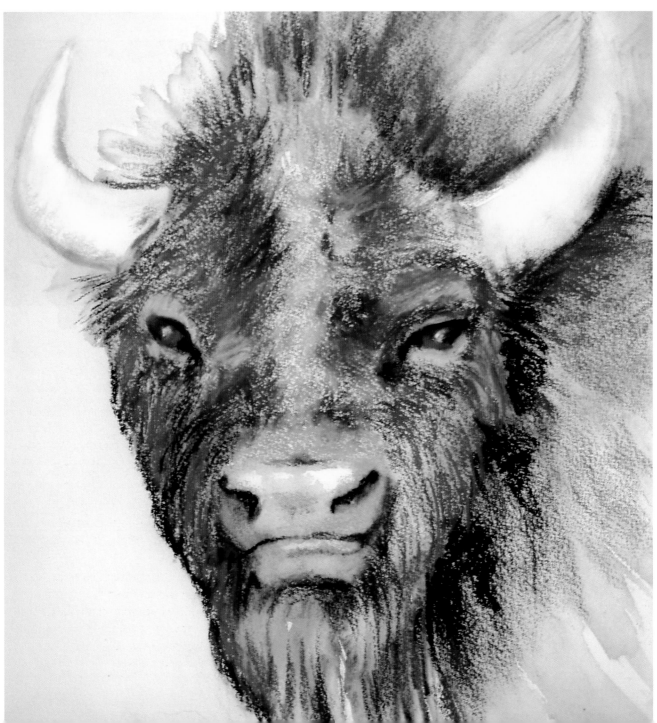

Another Dark-to-Light Bright Idea!

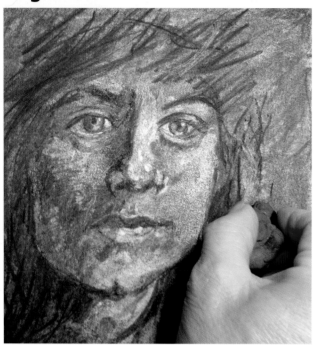

Apply a layer of soft charcoal (we recommend soft vine charcoal) lightly all over a sheet of white paper. Then lift highlights out by pressing with a kneadable eraser.

Go back in with charcoal or a black pastel for the deepest shaded areas. Then spray lightly with fixative. Geri added color to this example with soft pastel accents.

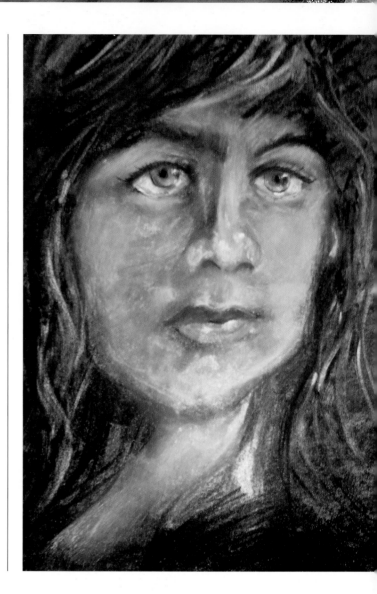

"Imagination is the eye of the soul."

—*Joseph Joubert*

six

6

The Water's Fine with Tempera

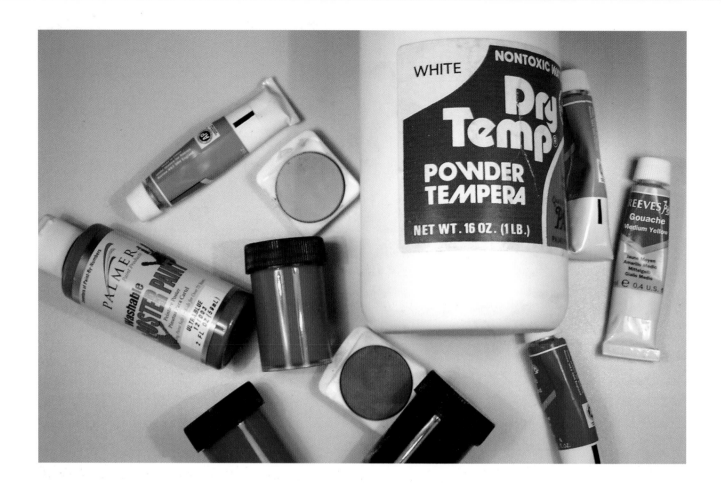

Tempera and other opaque watercolor paints can be used to make sophisticated pieces.

Tempera is an opaque water medium that's immediate, fast-drying, and convenient. Sometimes called poster paint, tempera paint can be purchased in powder form, in cakes or pans, or as a liquid.

Gouache, also referred to as "designer's color," is perhaps more similar to opaque watercolor than to tempera. It offers outstanding coverage and is available in cake, tube, or liquid form.

Tools & Materials

- Tempera paint
- Brushes
- Papers or other substrates
- Inks, acrylic paints and mediums, Conté pencils, gouache
- Bar soap
- Containers
- Cookie sheet

Painting Pointer

Don't overwork a tempera or gouache painting with too much of the same, as you may lift up some of the previous color.

MAKE YOUR MARK WITH CONTÉ

When working over tempera to change areas or add details, it's easy to accidentally lift the previous layer of tempera paint off. You can add fine detail with pastel or Conté pastel pencils (vividly-colored pastels encased in wood, allowing for sharpening) over dry tempera without fear of affecting the layer beneath.

Here's How

2. Add emphasis and details with Conté pencils. Substitute soft or hard pastels for the pastel pencils if you wish. This is your chance to correct any mistakes in the tempera painting, too.

3. Lightly spray the finished piece with fixative.

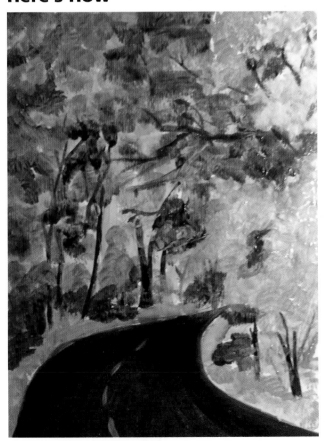

1. Paint with tempera as you see fit on the substrate of your choice. Let dry.

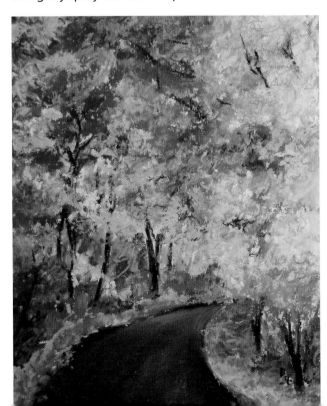

ADD TOUCHES OF TEMPERA

The substrate here is Strathmore Imperial watercolor paper. Acrylic washes were applied wet-into-wet (the paper was dampened first).

Bonus: If you make a mistake with tempera over dry acrylic, it's a simple matter to wipe it off! After the tempera (or gouache) accents are dry, the painting can be sealed with clear acrylic spray.

Overpaint acrylic washes with tempera, a little or a lot. The two media are well suited to each other.

Here's How

1. Mix acrylic paints with plenty of water and create a base painting using whatever subject matter you like. Let it dry before proceeding.

Green Scene

Delta Soy Paint is lead-free and non-toxic. It performs just like regular acrylic paint.

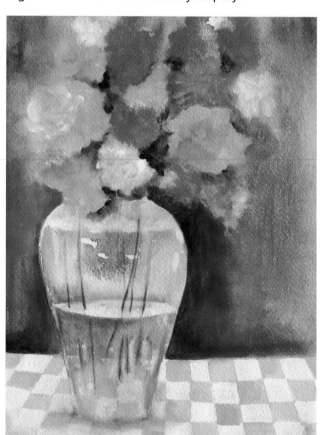

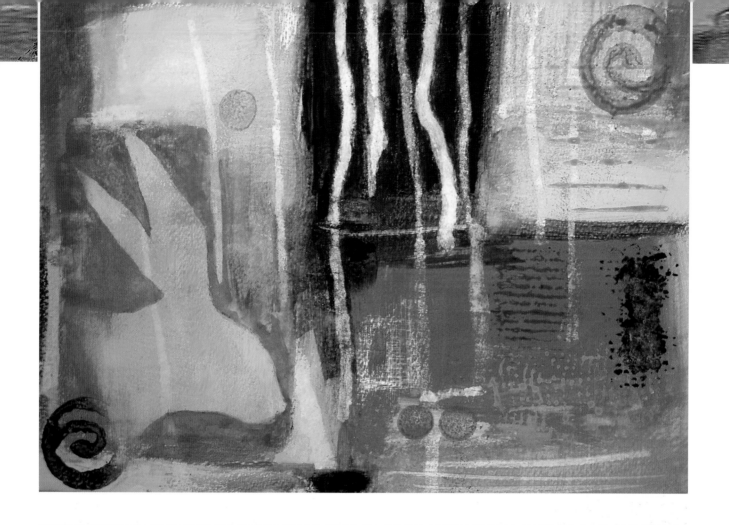

FAUX BATIK THREE WAYS

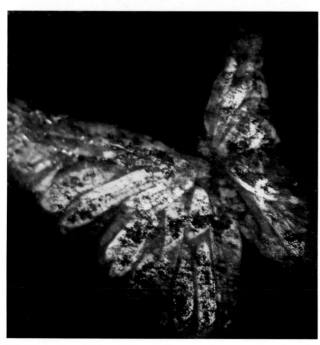

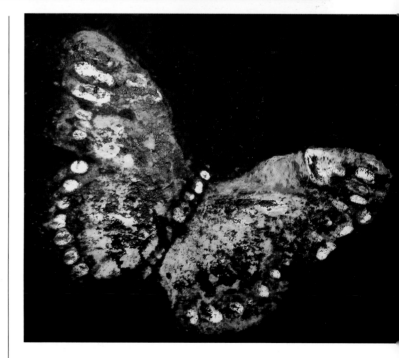

We'll begin with easy, batiklike washout methods on white or light-colored paper. Later we'll demonstrate how hand soap performs as a resist.

Here's How

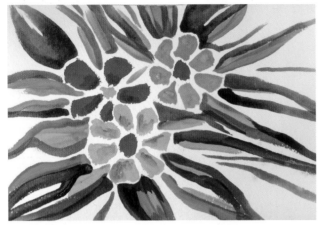

1. This painting will begin almost as a mosaic would, with enclosed spaces (positive and negative shapes). Choose white or manila paper as your substrate. We suggest a strong, absorbent paper such as watercolor paper.

Sketch with white chalk first if you wish. Then paint inside the shapes with heavy tempera, poster paint, or gouache (no black, please), leaving unpainted spaces between all the shapes. Apply the paint thickly. Avoid getting paint in the white negative spaces. Let dry.

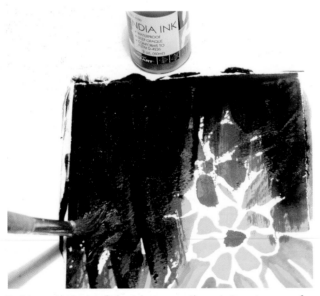

2. Use a large, soft brush to gently paint waterproof black ink (such as India ink) over the entire artwork. Don't scrub, but rather float the ink over the paper. Let dry.

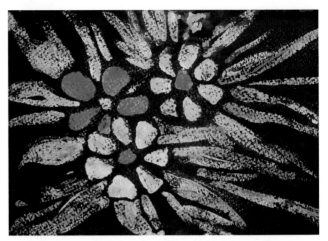

3. Lay the paper face up on the back of a cookie sheet, take it to the sink, and run a gentle stream of lukewarm water over it to remove much of the ink covering the paint. Lightly rub at stubborn areas; don't scrub vigorously. The tempera mostly resists the ink, and the negative spaces absorb the ink. When thoroughly dry, the finished artwork may require flattening with a warm iron or a large book. It can then be sprayed with clear acrylic if desired. (Read on to learn about two alternative sealants.)

White Tempera Resist

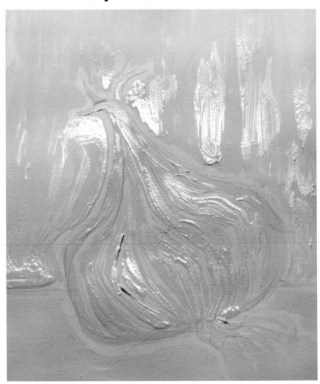

This is a simple variation on the wash-out project we just showed you. Select sturdy white paper, such as heavy watercolor paper. Draw in a basic pencil sketch lightly. With thick white tempera, paint over any of the lines and shapes that must remain white. Let dry.

Cover the entire paper with waterproof black India ink, applying it with a wide brush. Allow it to dry.

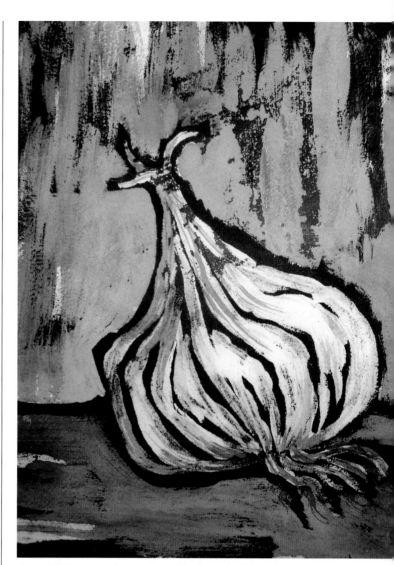

If you'd like to enhance the black and white design with color, wash in watercolors, colored inks, or thinned acrylics.

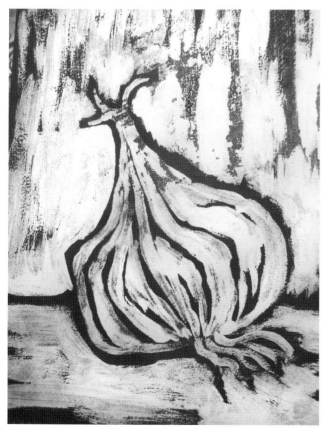

Then lay the paper in cold water and gently scrub or sponge the paper until the tempera paint lifts off, taking the black overlay with it.

Green Scene

Help save the environment and save money: use a shabby old shower curtain or tablecloth to protect your work area from drips, smears, and spills.

Be Sure to Wash with Soap

1. Black paper is a must for this project (construction paper is fine). Sketch with pencil or a water-soluble crayon, using a light hand.

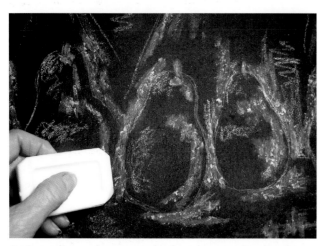

2. Draw lines, shapes, and edges by pressing hard with a bar of hand soap. Be mindful that, wherever you apply the soap, you're preserving some of the black paper.

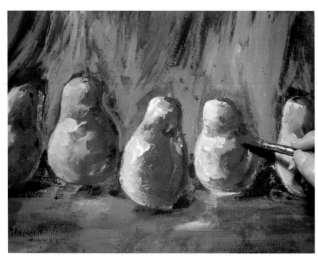

3. Paint in the design with tempera. Don't worry if you accidentally overlap some of the soaped lines or shapes.

4. When the tempera painting is dry, place it on a cookie sheet and take it to the sink. Run lukewarm water over it as you gently stroke your fingers over the painting. Too much scrubbing will cause the tempera to fade, but make an effort to remove all the soap.

Painting Pointer

One of the most pleasant tasks in creating a work of art is choosing a color harmony. Many art instruction books contain a color wheel, an excellent aid in selecting a scheme. If you usually reach for the same old hues, stretch yourself with a palette limited to warm colors, cools, or neutrals.

Analogous colors, next to each other on the color wheel, are always pleasing together. Or experiment with a *complementary* color scheme. Study up on these and more color harmonies in any good resource on color theory.

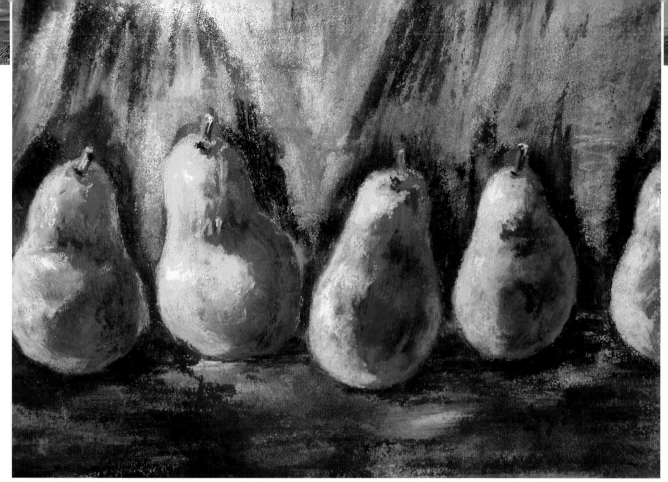

5. Dry the paper thoroughly. It will buckle unless you iron it or put a weight on top later. Some definition may be added where needed (we used oil pastels for a few accents, but tempera paint or soft pastels would do).

To seal the painting and make the colors more vibrant, apply self-leveling clear acrylic gel to the finished piece. Glossy gel medium works, too, but it does leave brush marks.

FLOAT YOUR BOAT FARTHER

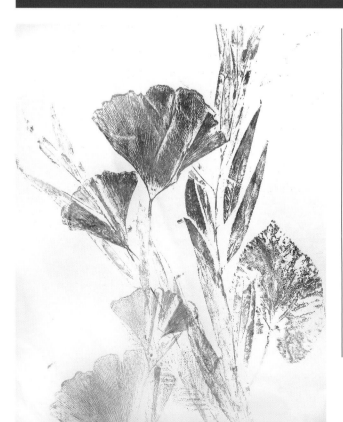

Reach into the vast pool of art supplies and techniques for more exciting adventures!

Stamp Act

Remember fruit and veggie printing in elementary school? Easy and fun, right? As an alternative, plant leaves with pronounced veins print very well. If you don't have fresh leaves handy, try other flat, textured items such as fabric scraps, ribbed rubber mats, or the rubber soles of shoes. Roll paint onto the articles with a brayer, or paint them with a large, flat brush. We suggest tempera, gouache, or acrylic paint. Press the painted side down onto the receiving paper.

Geri printed fresh ginkgo leaves with tempera, let it dry, and then added acrylic washes of color.

Drybrushing: Texture the Easy Way

Foliage, weathered wood or rock, a suggestion of fur or feathers—many surfaces can be conjured up with the drybrush technique.

You can use this approach with tempera, gouache, watercolors, acrylics, and oils.

Daub a dry brush into slightly thick paint. If you don't have a fan brush as pictured, spread the bristles of a regular brush with pressure from finger and thumb. Then hold the brush nearly parallel to the painting. Draw the very tips of the brush very lightly over the area to be enhanced, as shown at the right here. This method of applying an unblended layer (termed "broken color") allows whatever is underneath to show through here and there.

Hatch Back In

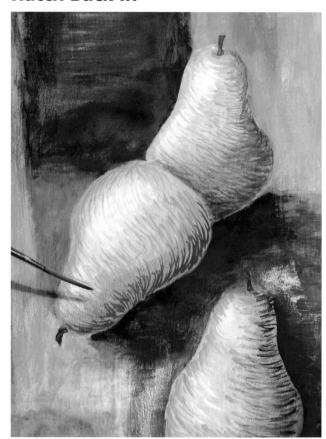

Hatching and cross-hatching are techniques used to create shaded effects with closely spaced lines.

You can achieve the appearance of volume with tempera or gouache and a fine liner brush. This method can also be used with watercolor paint. Lay in linear strokes that are at an angle and somewhat parallel. These are called "hatch marks." Feel free to wrap the hatching around a curvy form, as was done here.

The method is called "cross-hatching" when you add more lines over them, at roughly a right angle to the previous strokes.

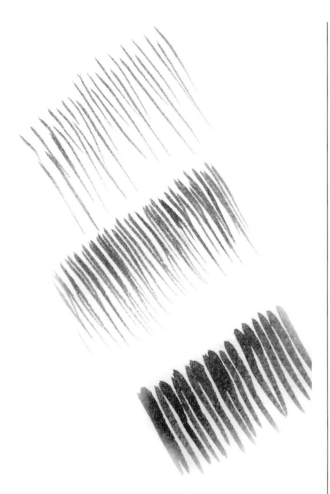

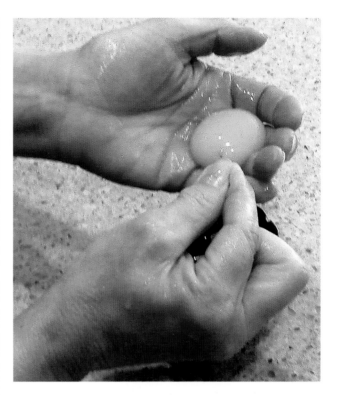

Create darker areas by increasing the number, thickness, and closeness of the lines.

Traditional Egg Tempera

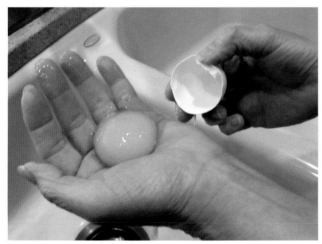

Let's go way back in time, to when paint was made from powdered pigment, egg yolk, and water. You'll need powdered tempera and several small containers. Mix a small amount of tempera color with just enough water to make a paste. Make an amount of pigment paste about the volume of an egg yolk.

Drain the white from the egg. Use the tip of a sharp instrument to pierce the yolk sac, and let its contents empty into the pigment paste as you retain the sac. The ratio should be about half yolk, half wet pigment. Blend the mixture well.

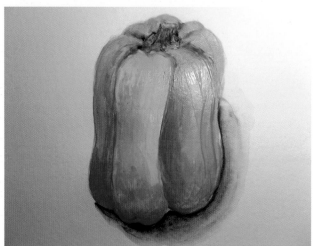

Geri painted the pepper's shadow with ordinary tempera so it would contrast with the lustrous egg tempera.

Finger Painting: It's Not Just for Kids

People of all ages can experience the joy and freedom of moving paint around with their fingers. It's so liberating to just play! Work on paper or illustration board. Move quickly, since tempera paint dries so quickly, or mist lightly with a spray bottle of water as needed. Wear rubber gloves if you prefer.

Portfolio
of Art

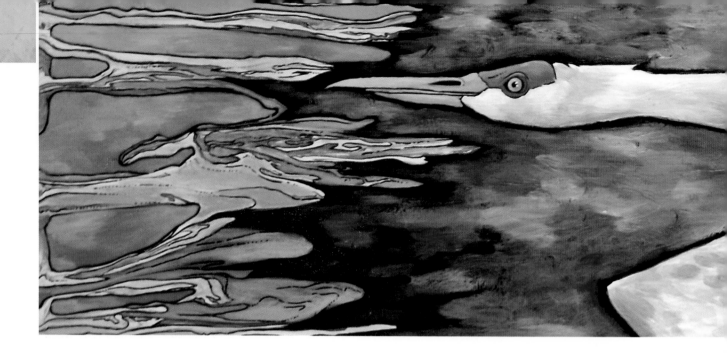

R ead each artist's narrative to learn how he or she created the works pictured in this exciting gallery.

"In Rapid Pursuit of Prometheus," by Jake Bosmoe, 2010. House paint, acrylic, paint marker, and varnish on hardboard, 12 by 60 inches.

"I started this piece by propping the long piece of hardboard up at a 15-degree angle. I then poured latex house paint and let gravity take it down the board. I continued to pour one color into another, creating a marbled effect. I encouraged the colors to run even more in areas by using a spray bottle of water. I later noticed the shape of a crane's neck and head in the paint, so I worked over the poured paint with acrylics to make the crane appear. I also added some background colors. Then I worked back into the piece with paint markers to define the tiny color changes in the poured paint (from the first step). Lastly, I applied a satin varnish over the entire surface to help protect the paint and to provide a rich luster."

"Charybdis Drinking of the Sea," by Jake Bosmoe, 2010. House paint, spray paint, acrylic, and paint marker on hardboard, 12 by 12 inches.

"This piece started as a very loose and free exercise in splatter painting. I worked with blue, yellow-orange, white, pink, and deep red house paints and just had fun dripping, throwing, and splattering colors. I then shot blasts of black spray paint at the wet paint from a very short distance, creating craters of black with some residual splattering around them. I also sprayed a thin layer of black around the edges to create a sort of vignette.

"I allowed all of this paint to dry and then worked back into the piece with black paint markers and light blue acrylic paint. I defined certain areas of the piece and used water to make the light blue paint fade away and overlay the previous layers. Next, I painted a solid black silhouette of the girl and bubbles in the water. I worked over the solid black with acrylics lastly, leaving black showing through for the shadows and line work."

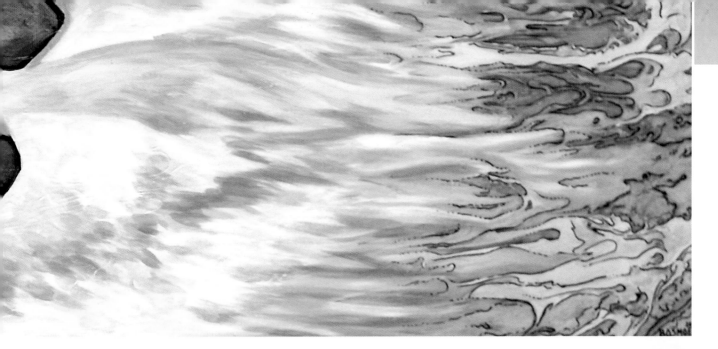

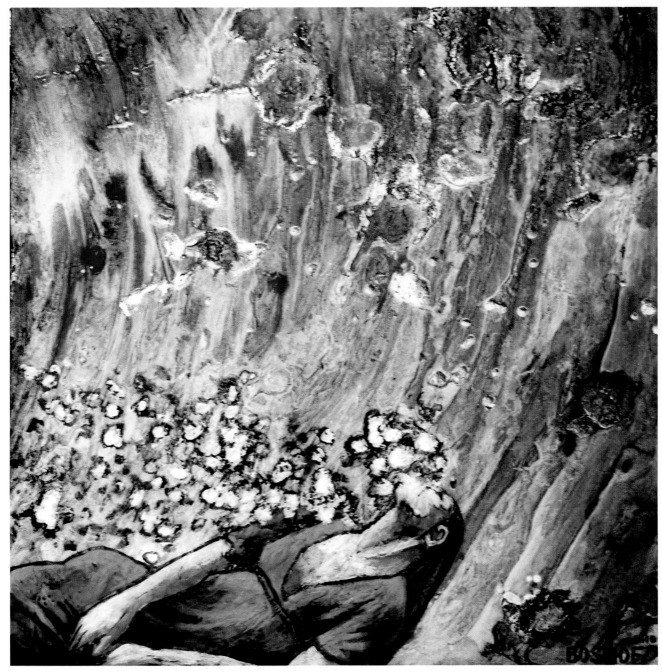

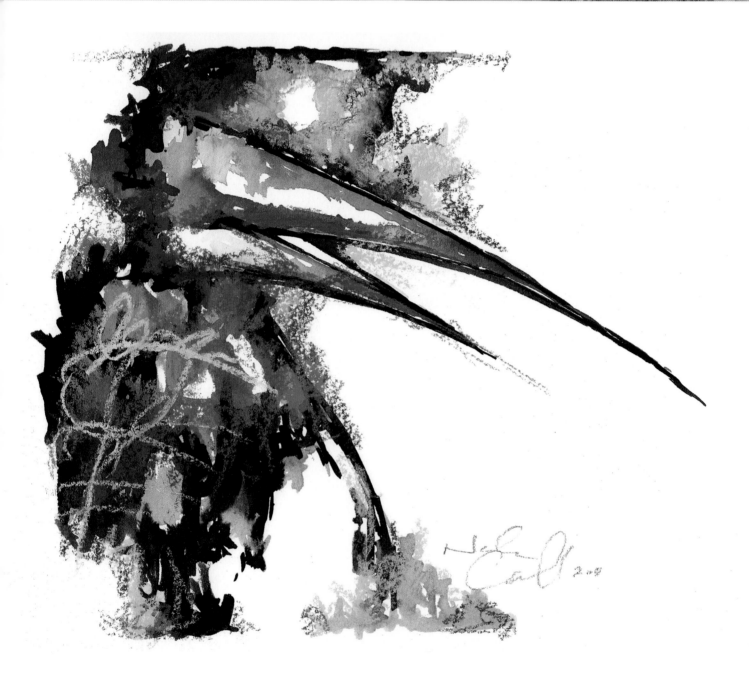

"Beak Study 3 (in Red and Yellow)," by Nathen Cantwell, 2010.
Watercolor, ink, pastel, on 11 by 8½ inch watercolor paper.
Collection of the artist.

 "I put down the initial watercolor washes, followed by a heavy use of ink in black and blues. Once the paint and ink dried, I used chalk pastel to highlight and darken areas of the painting and to give it a more frenzied appearance."

"Beak Study 4 (in Green and Blue)," by Nathen Cantwell, 2010.
Watercolor, ink, pastel, on 11 by 8 ½ inch watercolor paper.
Collection of the artist.
 "Watercolor washes came first, then quite a bit of black and blue ink. Later,
I highlighted and shaded some areas with chalk pastel."

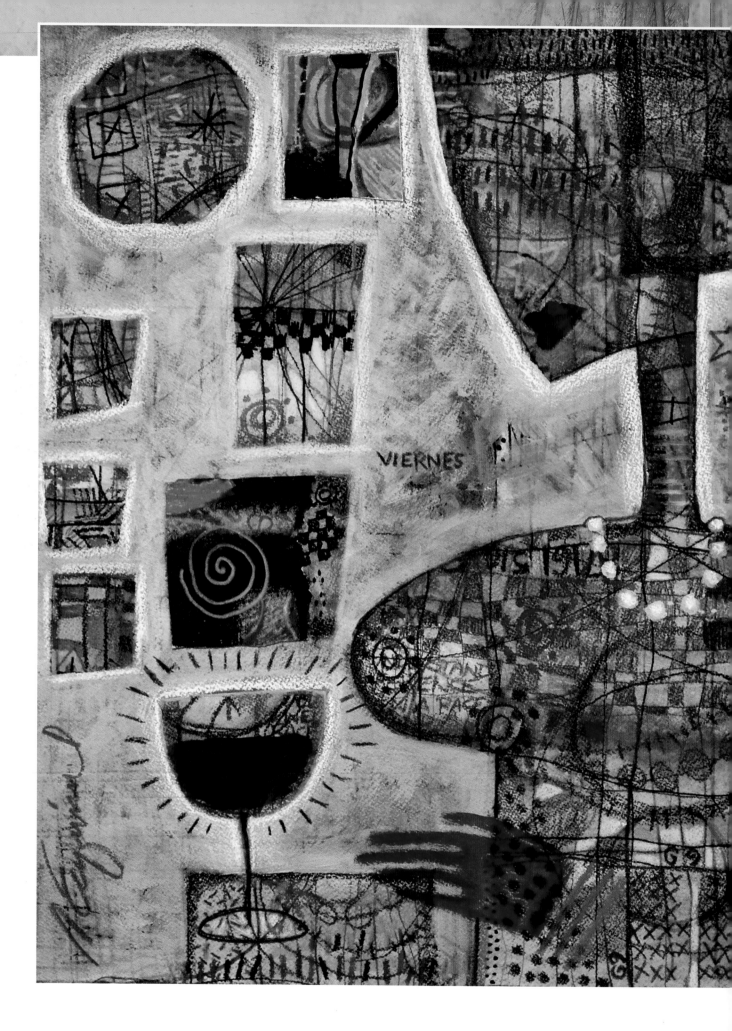

**"First Friday," by Robert Esquivel, 2010.
Mixed media on 16 by 20 inch watercolor paper.
Collection of the artist.**

"All the local galleries where I live feature an Art Walk on the first Friday of each month. Although the attendees can include some real art-lovers, there are those nights when everyone seems more interested in the wine and snacks than the art.

"I used a sheet of cold-press Arches watercolor paper. Random lines and images were freely drawn on the surface using a combination of graphite sticks and a Sharpie. The second step involved shading various areas with dry pastel. Next, water was applied to these dry pastel areas with a paintbrush. This allows the color to spread smoothly and be absorbed by the watercolor paper.

"After this, additional ink and graphite work was done, bringing out shapes and images that seem to guide me to the next phase. By this time, a subject began to emerge. Shape definition was further enhanced with acrylic paint. After that step, I used oil pastel to increase detail and definition even more."

"Because We Love to Watch," by Robert Esquivel, 2010. 18 by 24 inch canvas. Collection of the artist.

"I practice a kind of intuitive, free-form painting that focuses on randomness, happy accidents, and free association. The 'underpainting' technique I use is derived from a love of Abstract Expressionism. In this process, the artist's subconscious plays a major role in the creation of finished works. All my work begins with a celebration of paint, color, and texture. It is after this underpainted, expressionistic part is complete that the intuitive brings out the subject matter and the ultimate direction the painting will take.

"This piece is a winking comment on the voyeuristic nature of our society. Hidden-camera 'news' shows, and 'reality' television are probably the best examples of what I mean. So many of us are content to live vicariously through the adventures (and misadventures) of others. I used a Sharpie, acrylic paint, oil pastel, and a graphite stick, with a method very similar to that used with 'The Lost Guitar,' (page 111)."

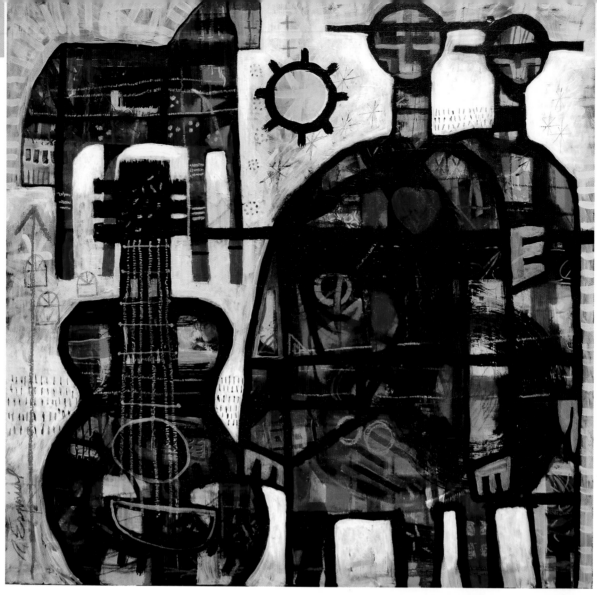

"Fall Ephemera," by Cheryl Holz, 2010. 10 by 204 inches. Collection of the artist.

"The three panels that make up this triptych were begun in 2008. I had gessoed many 8 by 10 panels of masonite to experiment on. First, I put down a base layer of poured and diluted inks. Many months later, I collaged on the old sheet music and journal pages. I had just started experimenting with acetone transfers at the time, so the plant in the right panel was put on that way. Then they sat there for over two more years! I finally pulled them back out and went into them with gesso and ink pours. I painted, drew back into the relief areas to bring them out, and then thought I had gone too far, so I tinted some gesso with yellow and 'erased' some of the areas. Stains and glazes enhance the low relief."

"The Lost Guitar," by Robert Esquivel, 2010.
24 by 24 inch masonite. Collection of the artist.

"My grandfather came to Nebraska from Jalisco, Mexico, in 1910. He lost a finger in an accident, but he didn't let that stop him from playing the guitar. One of my earliest memories is of my grandparents tearfully singing old Mexican folk songs together as he played. After he died, his guitar disappeared. I'm sure someone in the family has it put away, but nobody's talking.

"I primed the masonite surface with a coat of latex-based spray enamel. Next, I applied random areas of acrylic paint and accented with oil pastel. I added layers of paint and pastel carefully as suggested areas began to become more defined. Once the subject matter began to take shape, I used an off-white acrylic paint to paint out the unnecessary areas, bringing out the subject. Additional detail was added with oil pastel and graphite stick."

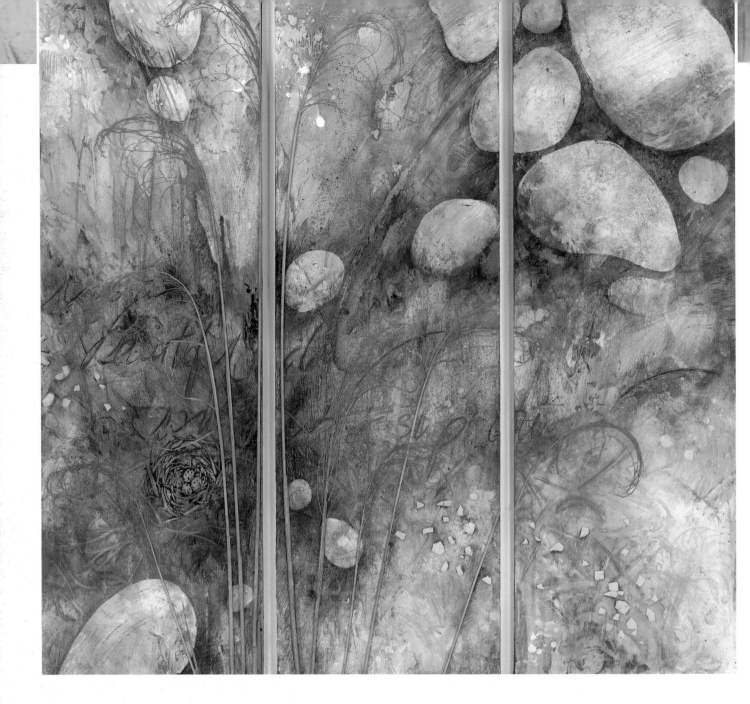

"Sand, Stone, Sky," by Cheryl Holz, 2008. 36 by 36 inches. Collection of the artist.

"My surroundings have an effect on me—this piece was begun in a park. I started with a loose wash/pour of ochre, then washes of teal. A layer of gesso came next, which gave me the opportunity to scratch in the timely song lyrics—'beautiful day,' from the U2 song. Then I applied resist 'stones' and another wash of acrylic. I used pencil to draw back in and enhance edges and make surface changes. I silk-screened on the nest and glued on broken dove egg shells and dried grasses over a period of days. I sealed thoroughly with clear acrylic before proceeding. Finally, I stained and glazed with acrylics, gradually building up layers."

"World Language," by Cheryl Holz. 28 by 24 inches. Collection of the artist.

"This piece started with a work on paper, which was a departure for me. I usually work on panel. I stretched some watercolor paper, painted, collaged, and transferred on the portion with the globe and receipt from South America. I loved the piece, but wanted to 'couch' it in a larger piece. I did a loose underpainting on panel to support the paper piece, then collaged the paper piece onto it. Finally, I poured, painted, stenciled, and collaged on and around it to incorporate it into the entire work."

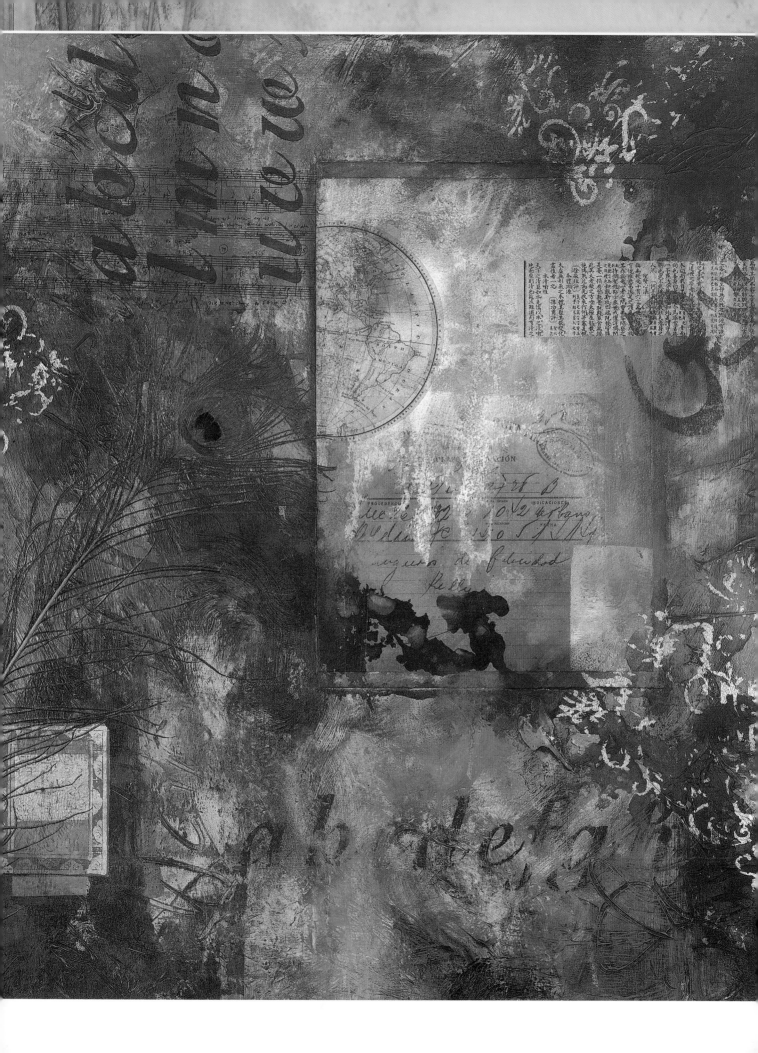

"Just Practice This Birdcall," by Dreama J. Kattenbraker.
36 by 48 inch stretched, gallery-wrapped canvas.

 "Scrim or cheesecloth pieces were attached with heavy gel medium to the surface of the raw canvas, followed by a sandy-textured medium in some areas. Next, three coats of gesso followed by one coat of lime-green acrylic were applied over all. I applied deep umber fluid acrylic with a fine-point brush to outline figures as well as architectural and design elements of the composition. I painted details on the figures using acrylic paint adjusted with matte mediums in multi-layered color glazes to create 'history.' An aged appearance is achieved by removing paint when wet or by sanding off dried areas. My next step was to incorporate collaged paper ephemera, attaching them to the canvas with matte gel medium. I 'build' a painting with relief elements of multi-textured mediums, collaged elements, and multiple types of paint or ink.

 "Acrylic painting blends the collaged elements into the whole. Gold leaf was attached to the crown with matte medium. At this point, I used either a brush or a pen to add waterproof ink designs. The entire piece was sealed using a satin-finish medium. After that was dry, I added a product that protects the entire piece from ultraviolet rays and fading. Finally, after it dried overnight, I rubbed oil paint sticks over any raised, textured areas. The qualities of oil, including its luminosity, are hard to match."

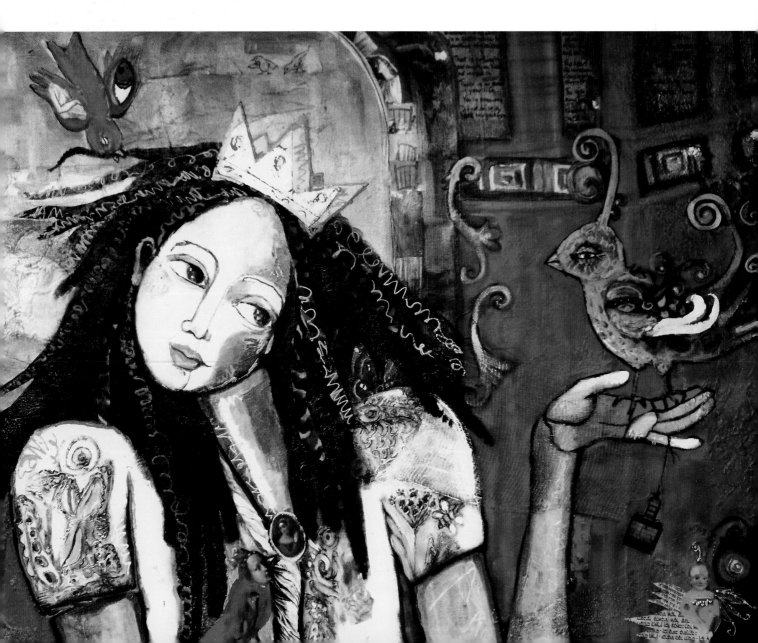

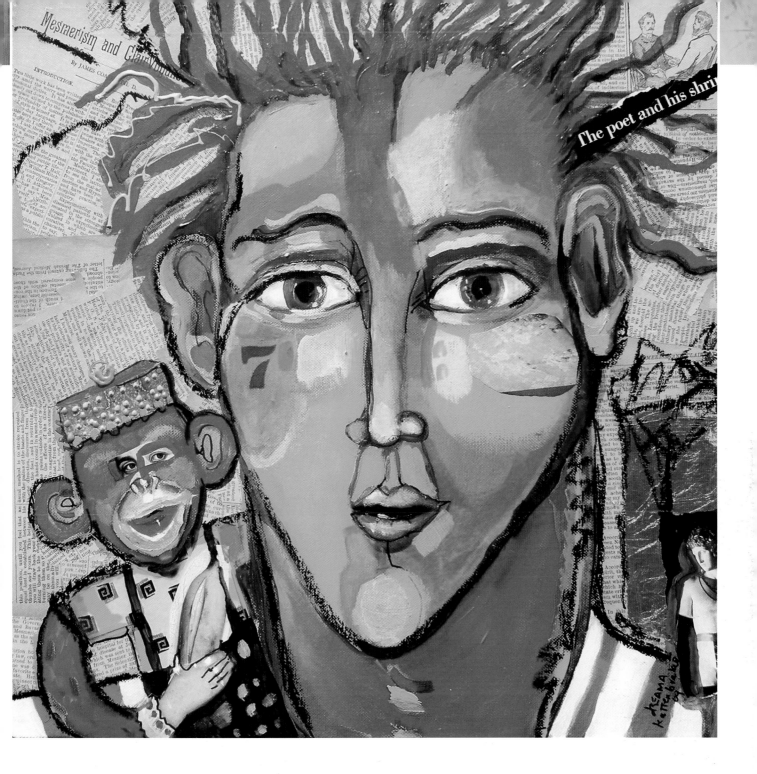

"The Poet and His Shrine," by Dreama J. Kattenbraker.
18 by 18 inch stretched, gallery-wrapped canvas.

"I outlined compositional figures with a medium-sized, pointed brush dipped into cerulean blue acrylic. The background behind the figures was collaged: I adhered vintage book pages using matte liquid medium. Details of the figures were then painted with acrylic. Further collaged elements, including copper metal leaf and a stenciled number, were added. Textural lines and 'beads' or dimensional dots were added with thick 3D paints applied from small bottles with nozzle tops (these paints can take hours to dry completely).

"I drew lines in the two faces with waterproof black ink in a fine-tip pen. The entire surface was sealed with a combination of liquid matte and gloss medium. (Gloss medium over metal leaf maintains the shiny metallic sheen.) Lastly, I scribbled and outlined with a black oil stick, adding additional texture. To me, oil sticks create the fresh and childlike effect of a giant crayon."

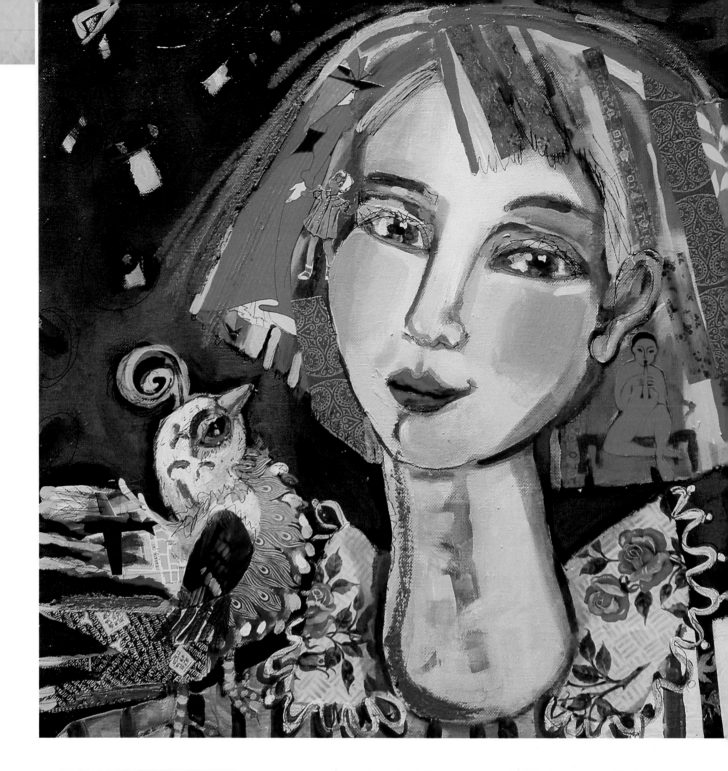

"Released from the Spell," by Dreama J. Kattenbraker.
18 by 18 inch stretched, gallery-wrapped canvas.
 "I gessoed the canvas and (when that was dry) I painted the background with lime-green acrylic. Then I outlined the main figures with a fine brush in medium blue. The details of both the bird and the girl figure were painted in next. After shapes and colors were established, I attached collaged paper elements with liquid matte medium or heavy gel matte medium, depending on the thickness of the paper. Additional acrylic painting connected collaged elements to the original painting. Waterproof ink in a fine-tip pen was added to create diverse detailed texture. I mixed matte and gloss liquid acrylic mediums together to seal the piece. The hair was treated with a heavy gel gloss and a texture comb was pulled through it to create relief. After the surface was completely dry, I added a final, bold color with an oil stick to exaggerate important marks."

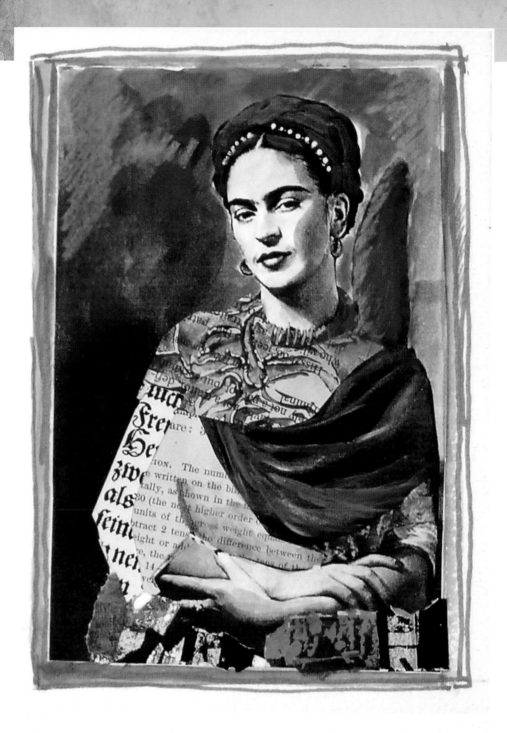

"Frida," by Nancy Standlee. 6¼ by 4¼ inch mixed media collage in a journal, on Kilimanjaro 140-pound watercolor paper. Collection of the artist.

"This was an image used in teaching one of my 'Love Your Life' art journaling workshops. The procedure is to take an antique photo or one of your choice and enlarge it on a copier to the desired size. (Interesting effects can be done first with the cutout feature in a photo manipulation program like Photoshop Elements before printing, if desired.) Copy it on a toner printer, as ink jet copies may blur. Adjust the contrast setting of the copier to get a lighter print. Trace around the shapes of the clothing for the collage. Glue the image down and brush a little medium over it to set the dye. Let dry while choosing the traced shapes for the collage clothing pieces.

"For the collage, use newsprint, hand painted and stamped papers, or magazine pages. Attach the clothing. (If you cut the shapes slightly smaller some of the black toner edges will show and add interest.) Glaze color on face, limbs, or clothing with acrylic tube or liquid colors, thinned down. For a little extra color, add markings with oil-based colored pencils and outline the image with white or gold pens or Sharpie poster paint pens."

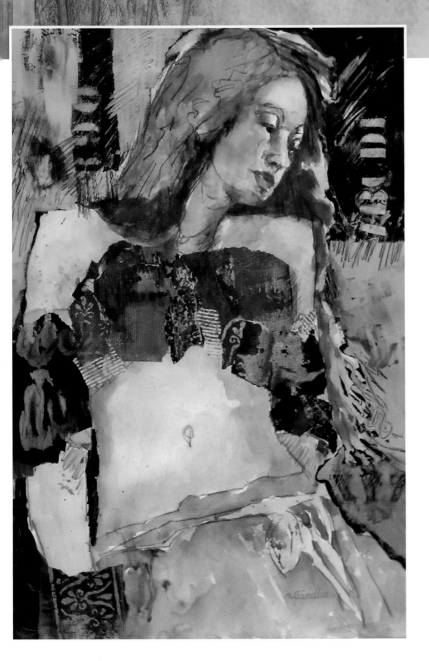

"Jessie," by Nancy Standlee.
22 by 15 inch, 140-pound watercolor paper.
Collection of the artist.

"My process here was to sketch with charcoal. You can fix or not, it's your choice. Use watercolor for the figure and negative paint around the figure using black and Daniel Smith gold gesso, alternating. I used a stencil with the gold for some lettering on the black, letting some of the previous painting history show. Negative paint with Matisse Derivan Structure Acrylic in sky blue. Scratch back into the gesso for additional interest while still damp. Use hand-painted papers or found papers to collage and decorate the bodice part of the figure. Frame under glass."

Texas Cactus, by Nancy Standlee.
10 by 8 in. Ampersand cradled gessoboard. Collection of the artist.

"I took the photo that inspired this piece in Fort Worth, Texas. I stained the edges a light walnut and underpainted the support with a red ground using Derivan Matisse China Red, a highly pigmented, low-tooth gesso. When that was dry, I used Sennelier, Holbein, and Art Aspirer oil pastels to build up the image with layers of color. It's important to let some of the background color show through in places. Afterward, I sprayed with a finish coat of d'Artigny fixative by Sennelier to protect against dust and smearing."

"As Seen on TV," by Brian Sullivan. 60 by 45 inch stretched canvas.

 "I begin each painting with some underpainting in acrylics. I then fill in everything in oil paint (because of its vibrancy and creaminess). Here I laid down a thin lace with flower patterns in the aqua area and sprayed black paint through the lace. Finally, I traced a stencil of David and hand-painted it in."

"Big Orange C," by Brian Sullivan. 60 by 45 inch stretched canvas.

 "I used the same process here as with 'As Seen on TV': acrylic underpainting followed by oils. Next I laid alphabet stencils on the canvas and sponged the color through them."

**"Letter R," by Laura Lein-Svencner. 6 by 6 inch watercolor paper.
Private collection.**

"I altered magazine pages with CitraSolv and let them dry before collaging them to the substrate. Acrylic glazing was added over the entire surface. Image transfers of black alphabet letters were added after that. I applied acrylic molding paste through a stencil (the two rows near the bottom) and let it dry. More acrylic glazing enhanced the piece. Oil paints were then rubbed in and around the dimensional area to help it stand out."

"Mondrian Kiss-Wham-O," by Brian Sullivan. 60 by 45 inch stretched canvas.

"After painting with oils over acrylics, I laid a thin lace with flower patterns over the white and red areas and sprayed black paint through the lace. Finally, I traced stencils of cupid and the cowboy and hand-painted them."

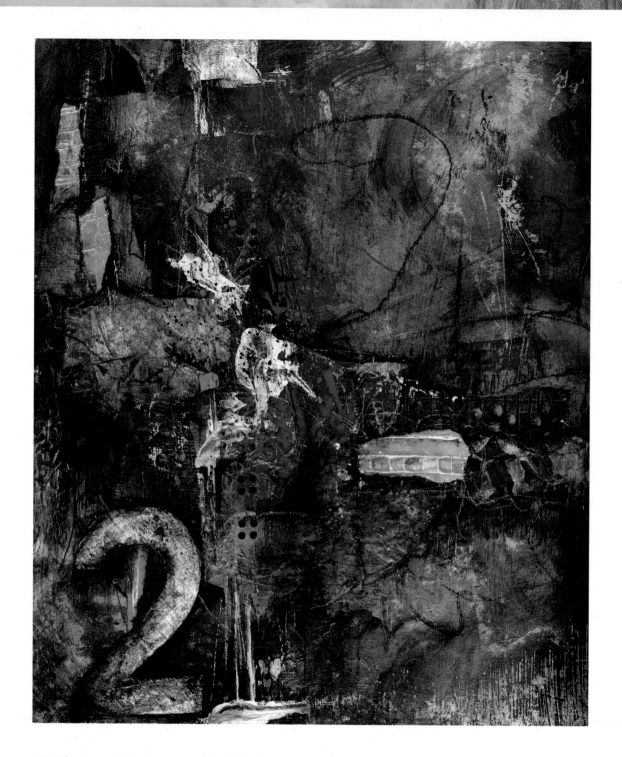

"#2," by Laura Lein-Svencner. 8 by 10 inch 140-pound watercolor paper.

"I applied a dark hue of acrylic paint first with a brush, then placed plastic wrap over the wet paint. I picked up the plastic and laid it down again and repeated the process with a light hue. When I had the desired foundation, I let it dry. Next, I used a black charcoal pencil to make gesture lines with my opposite hand, to free me up a bit. I sprayed the charcoal with fixative to seal in the line, let that dry, and then I selected collage papers.

"I used handmade (from plants from my backyard) papers and found papers that were crinkled, sanded, and repurposed. I coated them on both sides with soft gel medium and dried them with a hair dryer. I also coated the whole piece with polymer medium and let it dry. Then I laid out the collage papers where I thought the composition called for them, and I used a heat seal iron to tack the papers down. I intertwined the layers with acrylics and pastels."

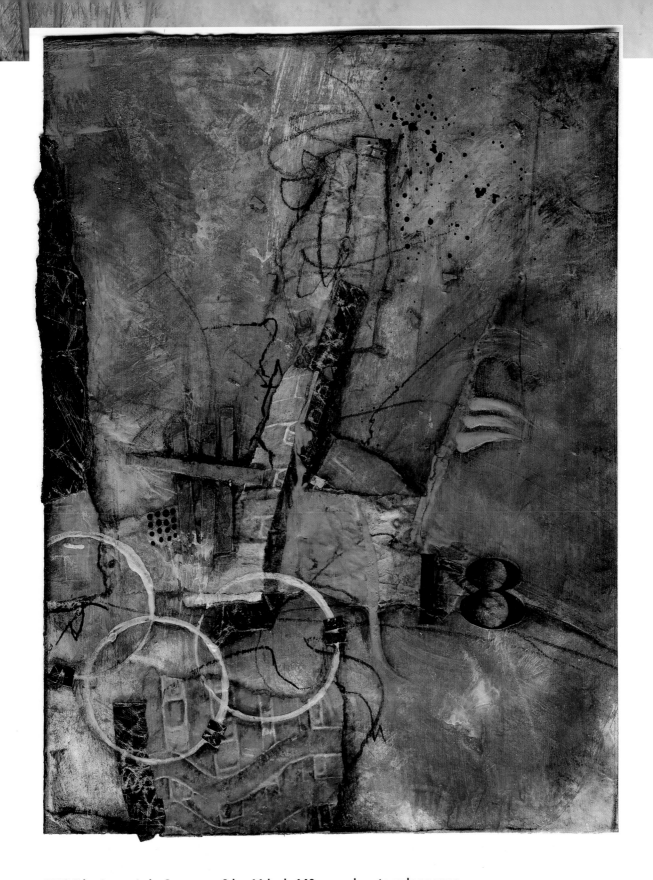

"#18," by Laura Lein-Svencner. 9 by 11 inch 140-pound watercolor paper.

"This was done with my own altered papers, acrylic paints and mediums, charcoal, pastels, and varnish. I fused the treated papers onto the substrate with a tack iron. The number 18 was originally reversed and laser printed onto soft gloss presentation paper and coated several times with polymer medium to build up a skin. I trimmed around the number, tacked it down, and sprayed it with water to rub off the paper backing. When the transferred number showed clearly, I sealed it with polymer."

Resources

Ampersand
1500 E. 4th St.
Austin, TX 78702
1-800-822-1939
www.ampersandart.com

Colorfin LLC
P.O. Box 825
Kutztown, PA 19530
1-484-646-9900
www.panpastel.com

Colourcraft (C&A) Ltd.
Unit 5, 555 Carlisle St. East
Sheffield, England S4 8DT
www.colourcraft-ltd.com

Creative Art Materials
4310 Cranwood Parkway
Warrensville Heights, OH 44128
216-518-0298
www.creativeartmaterials.com

Daniel Smith, Inc.
4150 First Ave. South
Seattle, WA 98134
1-800-426-5740
www.danielsmith.com

DecoArt, Inc.
P.O. Box 386
Stanford, KY 40484
1-800-367-3047
www.decoart.com

Delta Creative, Inc.
2690 Pellissier Pl.
City of Industry, CA 90601-1507
1-800-423-4135

Golden Artist Colors, Inc.
188 Bell Rd.
New Berlin, NY, 13411-9527
www.goldenpaints.com

Ranger Industries, Inc.
15 Park Rd.
Tinton Falls, NJ 07724
732-389-3535
www.rangerink.com

Rockland Industries, Inc.
1601 Edison Highway
Baltimore, MD 21213
410-522-2505
www.roc-lon.com

Sakura of America
Hayward, CA
1-800-776-6257
www.sakuraofamerica.com

Savoir-Faire
40 Leveroni Court
Novato, CA 94949
415-884-8090
www.savoirfaire.com

Strathmore Artist Papers
Pacon Corporation
1097 Ehlers Rd.
Neenah, WI 54956
www.strathmoreartist.com

Triarco Arts and Crafts
2600 Fernbrook Lane, Suite 100
Plymouth, MN 55447
763-559-5590
www.triarcoarts.com

Winsor & Newton
11 Constitution Ave.
Box 1396
Piscataway, NJ
1-800-445-4278
www.winsornewton.com

About the Contributing Artists

Jacob W. Bosmoe is an artist and art instructor from Aberdeen, South Dakota. He teaches middle school art at Simmons Middle School and loves to see the spark in students' eyes when they understand a new concept or surprise themselves with how well they can draw when they put their minds to it. Jacob has spent the last few years working primarily with watercolor and has just begun to dive back into acrylics and mixed media. When asked why he enjoys producing artwork, Jacob responded, "The act of creation is the only thing that makes me feel complete and satisfied. Sometimes I am creating lessons, or a new meal, or remodeling a room in my house instead of painting, but I am always thinking in terms of creation and always have."

Nathen Cantwell is an accomplished art director and fine artist residing in Minneapolis, Minnesota. Cantwell's art is rooted in the natural world and usually features blackbirds or crows as messengers or representations of ideas and emotions. For more information on Cantwell and his work, please visit www.cantwellart.com.

Robert Esquivel, who has a degree in education, has exhibited much of his work regularly in galleries and shows. In Robert's own words, "I have always had a love affair with color. Maybe it's my Latino background, maybe it was all those brightly colored crayons I ate when I was growing up. Whatever it was, my work, in whatever medium, is a celebration of color. My artistic influences come from Neo and Abstract Expressionism, inspired by elements of Art Brut, Indigenous Art, and Magical Realism. My subject matter comes from the mystery of the world around me, viewed through the lens of my artistic influences. I try to express in my work a glimpse into wherever I currently happen to be in my life's journey, and, as is not surprising, it seems to touch a common place in many viewers, since in the end, we are all travelers on the same road."

Cheryl Holz's rural upbringing had a big influence on her aesthetic sensibility, and most of her work today is an homage to nature's strength, beauty, and diversity. She has an undergraduate degree in art education, studied drawing and painting at California State at Northridge, and received her Master of Fine Arts in crafts from Northern Illinois University in 1990. Cheryl has received local and national recognition for her work and shows in galleries, museums, and juried shows throughout the country. Her work is included in many corporate collections and hospitals. When she's not working in her studio overlooking the Fox River, she enjoys tramping around local forest preserves with her dogs in tow.

Dreama J. Kattenbraker lives in Fincastle, Virginia, but has resided in twenty-six homes, two foreign countries, and thirteen towns or cities in the United States. She says making art has been the one constant in her life. She creates ceramic and mixed media sculpture, paintings, collages, and assemblages. Dreama's style has been described as "magical impressionistic narrative" and often "whimsical." Her award-winning work has been exhibited widely.

"I'm grateful for the full circle that creativity provides: sharing and learning from others; the intimate process of working alone to resolve a puzzling idea, and finally seeing how others respond and interpret the creative results for themselves," she says.

Nancy Johnson Standlee, a native Texan, attended Tarleton State University. She retired as an elementary school librarian in 2000 and lives in Arlington, Texas.

Her focus is on bright colors and impressionist techniques, and she has added the medium of collage to her style, using her own hand-painted papers and found papers. Her artwork has evolved to acrylic semi-abstract figurative painting and mixed media paintings. Some of her recent work can be seen on her blog and website. Nancy also contributes to several other blogs and paints with a group, Canvas by Canvas, who paint collaboratively. She loves traveling and teaching art journaling workshops.

She says inspiration comes to her from a library of art books, viewing other artists' work, painting with friends, art workshops, museums, travel, photos— all that she sees and experiences. Visit her website at http://NancyStandlee.com and see her blog at http://NancyStandlee.blogspot.com.

Brian J. Sullivan has been called a master of using nontraditional materials and techniques in combination with each other. For several decades now, he has pushed the envelope not only of materials and processes but also content. He has exhibited his work throughout the United States, Europe, and Asia, winning many awards and accolades.

He makes use of disparate Americana and advertising images to create pictures layered with multiple meanings. His work is filled with emotion, narrative, sarcasm, irony, satire, political and social commentary, and symbolism. As an artist, Brian's goal is to create visceral works of art which in some way resonate within each viewer.

Artistic influences in Brian's work come from two diverse movements in art. The first is the Surrealist movement, exemplified by such artists as Giorgio de Chirico, Max Ernst, René Magritte, and Salvador Dali. The second biggest influence is the Pop movement, with artists such as Robert Rauschenberg, Richard Hamilton, Andy Warhol, James Rosenquist, and Eduardo Paolozzi. For more information, visit his website: www.BrianSullivanArt.com. Studio visits are always welcome.

Laura Lein-Svencner grew up in Downers Grove and resides in Darien, Illinois. She cofounded the Midwest Collage Society and is a member of many other local and international collage groups. During the summer months, you will find her exhibiting her artwork in art fairs and teaching collage workshops all over the Midwest. She loves handmade and altered paper, always incorporating it into her work. She delights in making acrylic skin transfers and exposing the raw edges of torn paper.

About the Authors

Geri Greenman has taught art for three decades and was nominated for a Golden Apple. She was a finalist for the international Dolores Kohl teaching award, and won the Outstanding Achievement Award at two schools. She is listed in the Who's Who Among America's Teachers.

Her award-winning artwork is shown in galleries in and around Chicago, and her poetry has been featured in *ArtsBeat* magazine. Geri has also had nineteen cover stories with *Arts & Activities,* the nation's leading art education magazine.

She lives in Geneva, Illinois, with her husband, and near to their daughters and grandchildren.

Paula Guhin is a wild woman at heart who is passionate about photography, painting, and mixed-media art. She's also mad about teaching and writing.

Her nonfiction books include *Creating Decorative Papers* and *Image Art Workshop,* among others. She and Geri also collaborated on *The Complete Photo Guide to Creative Painting.* Both authors are contributing editors at *Arts & Activities* magazine.

Paula lives in Aberdeen, South Dakota, with her compassionate, understanding husband, David. They support three horses, three adopted dogs, and two found cats. Visit Paula's blog at http://mixedmediamanic.blogspot.com.

Acknowledgments

Gratitude goes to all my former students, who inspired me to be a better teacher; I was privileged to have been a small part of your life. I value those memories.

—G. G.

We wish to thank Mark Allison and Kathryn Fulton for making this book not only possible, but better! Appreciation to the art and production directors as well, and our fabulous contributing artists.

—P. G.

Lastly, thanks to you, dear reader, from both of us. If your ship doesn't come in, swim out to it. Our best wishes go out to you for clear sailing ahead. Anchors aweigh!